SKIPTON
THROUGH TIME

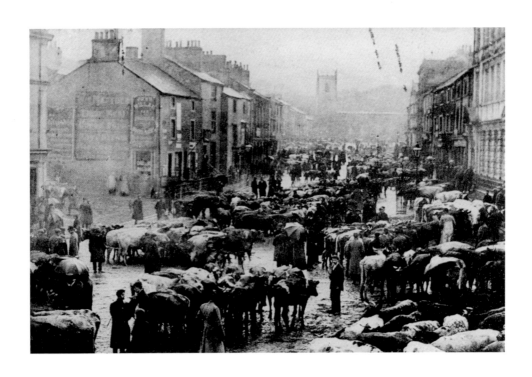

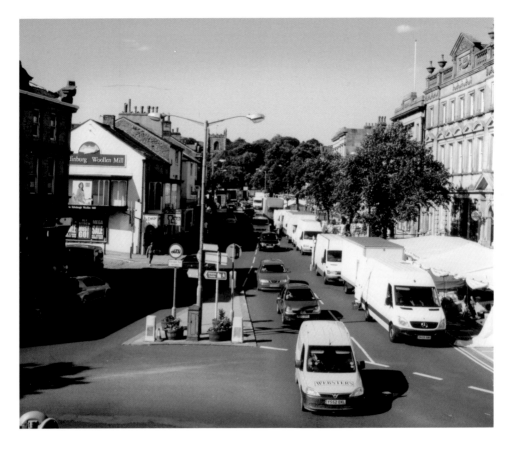

SKIPTON
THROUGH TIME
Ken Ellwood

AMBERLEY PUBLISHING

Frontispiece: There are many pictures of this fortnightly cattle fair held in the High Street but this one was taken on a particularly wet day causing a terrible mess underfoot. It was moved in 1906 to Jerry Croft, now the car park behind the town hall. Dr Rowley said that there were thirty years of argument about it. The prize winning High Steet today on one of the market days causing congestion of a different sort.

First published 2009

Amberley Publishing Plc
Cirencester Road, Chalford,
Stroud, Gloucestershire, GL6 8PE

www.amberley-books.com

Copyright © Ken Ellwood, 2009

The right of Ken Ellwood to be identified as the Author of this work has been asserted in accordance with the Copyrights, Designs and Patents Act 1988.

ISBN 978 1 84868 547 5

British Library Cataloguing in Publication Data.
A catalogue record for this book is available from the British Library.

Typeset in 9.5pt on 12pt Celeste.
Typesetting by Amberley Publishing.
Printed in the UK.

Introduction

I have written four books about Skipton using old photographs, and when I published *Skipton and the Dales,* I thought that it would be the last as I had used most of my collection.

Imagine my surprise and joy when Amberley Publishing invited me to write another in their *Through Time* series. This would give me a chance to use some of my colour photographs from the past as well as some more recent aerial views of Skipton.

So, I set off with old photographs in one hand, camera in the other, and this is the result!

I was soon in admiration of the photographers and wondered how they were able to get into position, for example, the High Street from an elevated position halfway up, towards the church.

When I came to Skipton in 1953 to take up the post of school dental officer, I thought that I had better read a little about the town. The first, which have stuck in my mind, were 'Skipton in Craven is never a haven but many a day of foul weather'. However, when Kath followed me to Skipton to work at Skipton General Hospital as a nurse, we were soon exploring this lovely town and were married in August. Kath worked in the operating theatre, helping surgeons Mr Macartney and Mr Shaw.

We found Skipton to be a market town where agriculture rubbed shoulders with industry. There were six or more mills working full time, some using large steam engines as motive power. I wish that one at least had been preserved; they were well cared for and the brass parts were polished until they shone by the engine men.

Seven years later, when I joined Bryan Hargreaves in his dental practice, I met many of the weavers and found them to be splendid people with a calm and disciplined outlook on life. Every Sunday, one could see them walking their favourite routes such as Halton East and Eastby to over 'white hills' to Stirton and Thorlby.

I can't remember any hooligans in the High Street on Friday or Saturday evenings. Kath and I lodged at the Brick Hall (now Woolly Sheep) at the bottom of Sheep Street.

There was a good auction mart near the station and we remember the dozens of Irishmen in the High Street waiting to be hired by the farmers at haymaking time. There was no need for supermarkets because there were plenty of good food shops such as Stockdale and Helm, Hodgsons, S and B Fruit Ltd, Carrs, Redmans, Maypole, quite a few butchers and five chemists. The market stalls were much less than now and appeared on Monday and Wednesday — they had developed from Fair Day, when all the cattle were traded in the High Street. This had to be moved to Jerry Croft behind the town hall.

My first work was at Ings School and there I met Bill Preston who later became head-teacher. Bill and his wife Sheila became our first friends in Skipton. Sheila made wonderful Yorkshire puddings.

To close, I would like to quote from the memories of Mrs Platt. She was born Annie Alderson in Skipton in 1907 and lived with her family in Brookside off the lower part of the High Street, which became their playground.

Well I've written down most of the things about old Skipton which I loved so much. Amongst my memories including standing in falling snow by the town hall at midnight on Christmas Eve waiting for the church bells to ring and the town band to play carols. I recall lying in my bed on winter evenings listening to my uncle, Robert Thornton, playing the piano in the house next door and also hearing the parish church clock striking the hours. Simple things but so full of happy memories it seems such a pity that those days have all gone.

Acknowledgements

Many people who were thanked in my previous books have passed away, among them Dr Rowley. In some of my captions I can hear his voice now; his wife Val continues to collect and show his slides.

Frank Knowles copied all our old photographs and slides and improved many of them and occasionally still does so. My duplicates are in the Craven Museum and Val has deposited prints in the Skipton library, which has now put many of them on the Internet.

The Yorkshire Trading Co., who followed Woolworths, allowed me to take pictures of the High Street. Phase Eight also let me take photographs of Upper High Street. Tony Harman of Maple Leaf Images developed the new photographs and has put them onto disk for me.

The girls who work for Max Spielman have copied with great enthusiasm. Joan Whitaker, daughter of Mr Hodgson, loaned a photograph of the family business in Sheep Street.

Kath, my wife, helped by holding the old photographs in position and holding onto things as I wandered from place to place. She also had to put up with photographs spread out on two beds and around my chair in our dining room!

Finally, my daughters-in-law, Mandy and Helen, and my grandson Rory typed the captions.

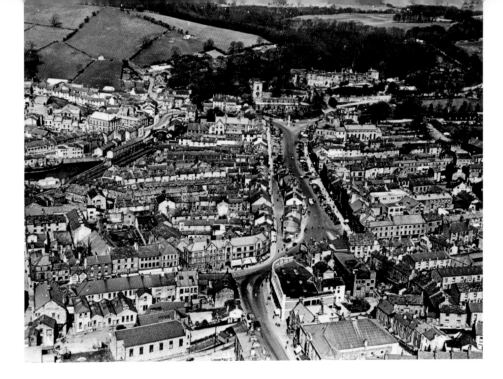

Aerial Views of Skipton

Here is an aerial view of our town taken in 1949 and it is so sharp one can see all the buildings as they were in the previous fifty years. The second view was recorded in 2004, flying from Blackpool when the Civic Society was preparing a series of maps of Skipton in the past. Compare the two photographs and note how well the church and castle stand at the top of our prize-winning High Street, but note the changes since 1949. A new Skipton Building Society and new development in the Albert Street area; many of the yards have gone. Note the car park in Jerry Croft behind the town hall.

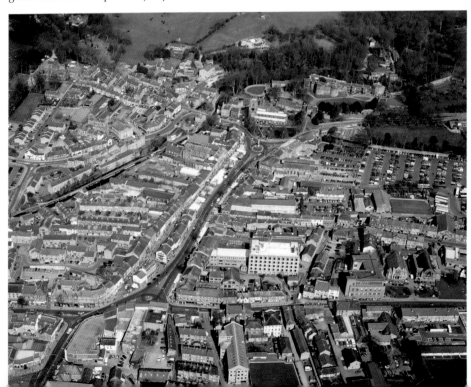

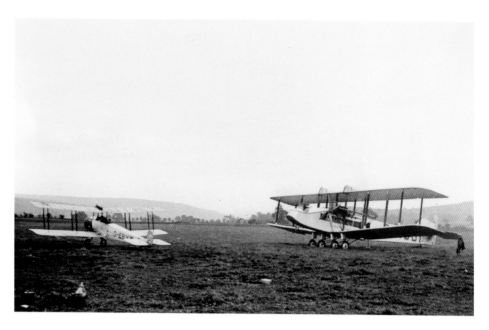

The Airfield

Skipton, October 1932. On the left is Avro 504 K G-EBYW of Aviation Tours. On the right is Handley Page W8bG-EBBI, owned by Imperial Airways but used during 1932 by Earl Fieldon of Aviation Tours Ltd and flown by him for Cobham. The moor above Kildwick is on the left and Carleton Moor is on the right. Earl Fieldon was a Skipton man and lived on Raikes Road. Sir Alan Cobham addressed the Skipton Rotarians at that time and, as reported in the *Craven Herald*, he said every town the size of Skipton should have a small aerodrome. The picture below, taken in July 2009, is from a little further back behind the old railway line from Skipton to Calne. There is a move afoot to reopen this route to Lancashire.

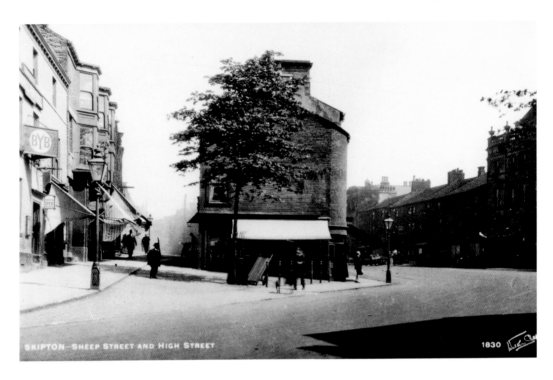

SKIPTON—SHEEP STREET AND HIGH STREET. 1830

Sheep Street

Pictured is the lower end of Sheep Street with the Brick Hall Inn, now the Woolly Sheep, on the left; it was a Bentley's Yorkshire Brewery pub. There is not a lot of difference between then and now, but this March photograph shows off the tree with no leaves.

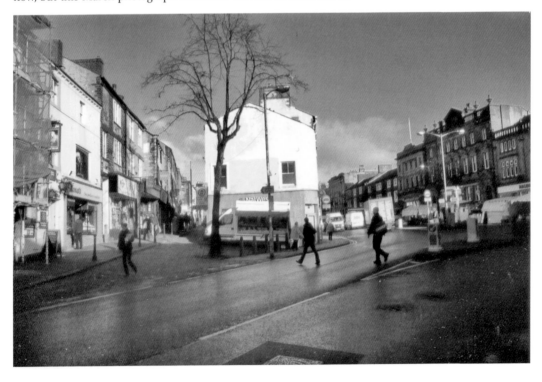

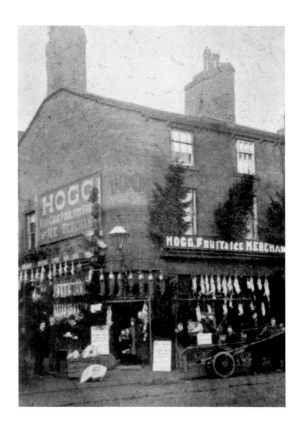

No. 100 High Street
No. 100 High Street was occupied by
Hogg, fruit, poultry and ice merchants.
The number 100 on the right of
Hogg could be seen until recently.
This building, along with Exchange
Buildings, is now occupied by the
Natwest bank.

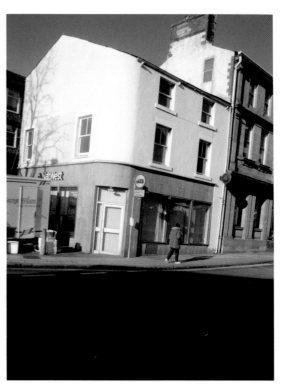

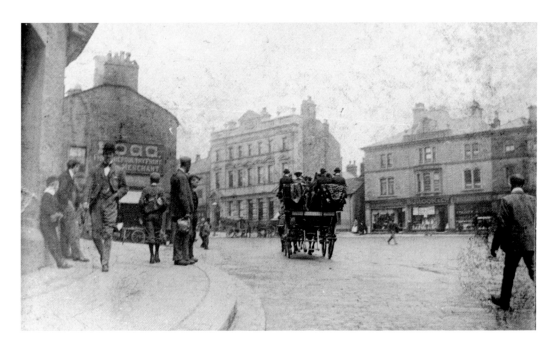

Caroline Square

The entrance into the wide Caroline Square shows both the Midland Bank and High Street House, but the Wheatsheaf is still squeezed in between so the date must be between 1888 and 1908. Part of the new Ship Hotel can be seen on the left. A recent picture has been taken from the same position. The market stalls obscure the shops. The trees are now 112 years old and, as you will see later, they still produce beautiful green foliage.

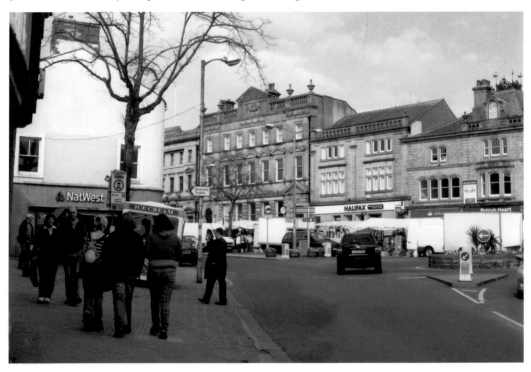

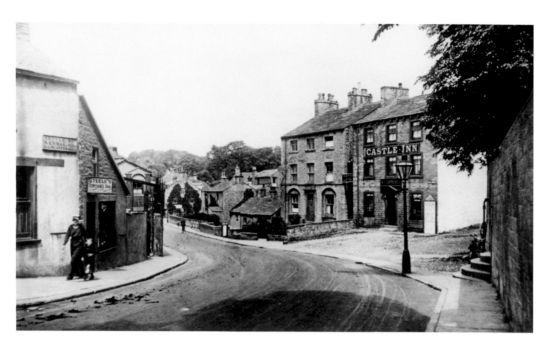

Leaving the High Street

These photographs show the view from the side of the churchyard to the canal bridge. The photograph below was taken in the spring of 2009.

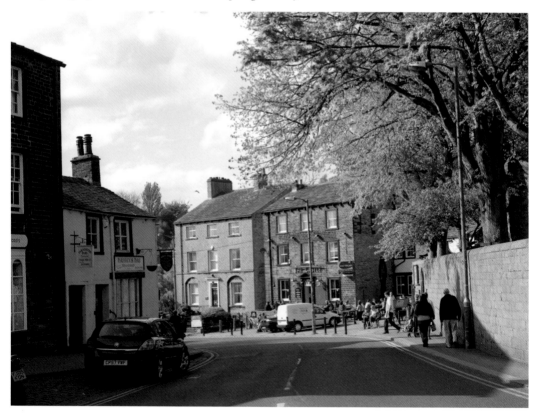

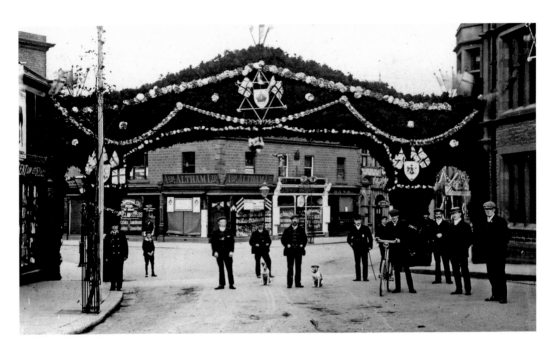

The Archway

This arch was erected to celebrate the coronation of George V in 1911. The Ship hotel is on the right. Through the archway are shops, converted from the Christ Church vicarage. The scene in March 2009 shows that Dolland & Aitchison have moved into the premises previously occupied by Barclays Bank.

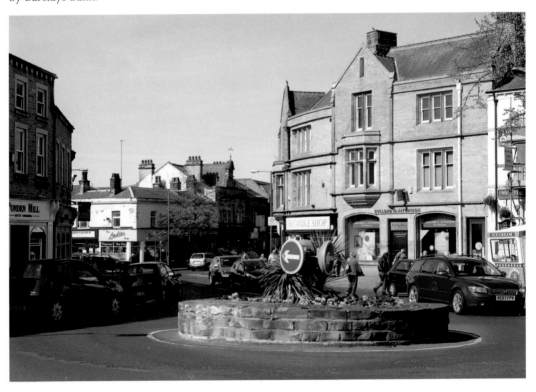

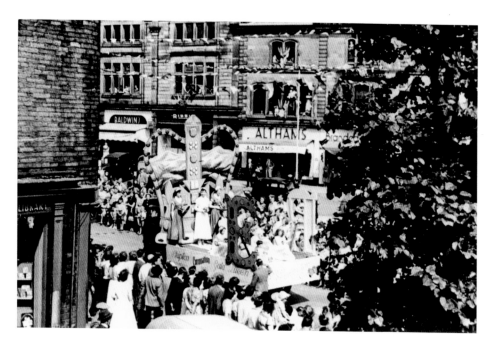

Caroline Square

Before moving up the High Street, we should explore Caroline Square. This first picture was taken from the Brick Hall Inn, now the Woolly Sheep, where I lodged in 1953. It shows the Skipton Gala Queen moving up the High Street. The photographer was George Prochok, a 'displaced person' from Rovno in the Ukraine. He went home in 1954 and trained as a teacher. The silver jubilee was the subject of this picture, taken by me from my surgery next door to Brick Hall. George was still alive and well in the Ukraine and working as a teacher. We were well looked after by Mr and Mrs Burke who had the Brick. I think the crane was working on the new Skipton Building Society.

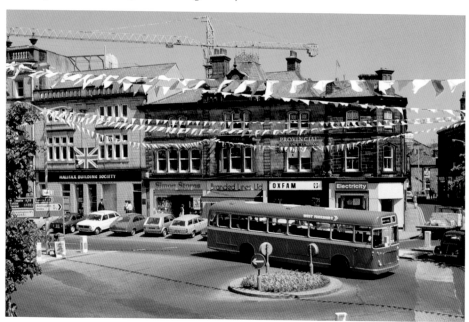

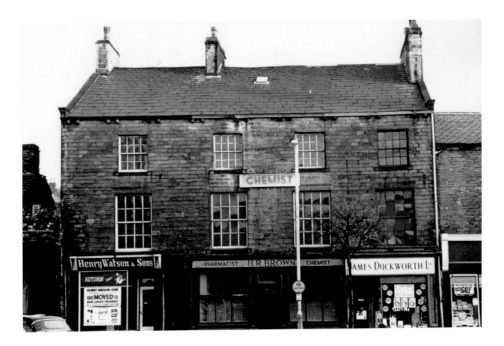

A View Through the Gap

H. R. Brown, chemist and pharmacist, closed his shop in 1965. It was situated in Caroline Square at the bottom of High Street and was No. 77. His son Jeffrey told me that his bedroom was under the skylight. He thinks the whole building was demolished in 1966. I took this photograph to show the top of Castle Street seen through the gap after the chemist's shop, now demolished. The large tree is still there. I have no idea of what happened to the small, pretty tree, one of those planted in 1897 for Queen Victoria's jubilee. Superdrug, a modern building, is there now.

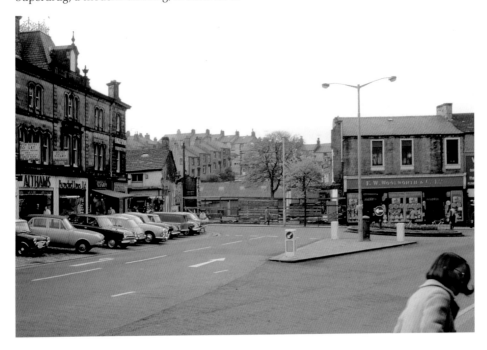

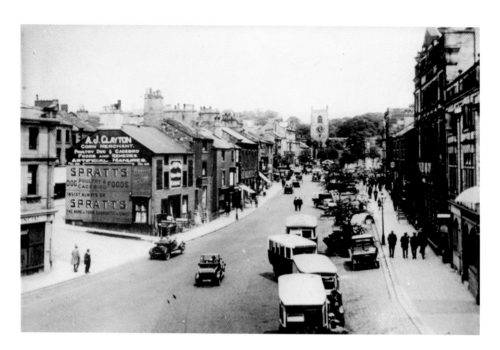

Skipton Bus Station
Caroline Square at the foot of the High Street was the home of Skipton's bus station, 1920s or early '30s. The photograph was taken at 12.25 p.m. Compare this with the photograph taken in 1982, which shows a gradual build up of traffic.

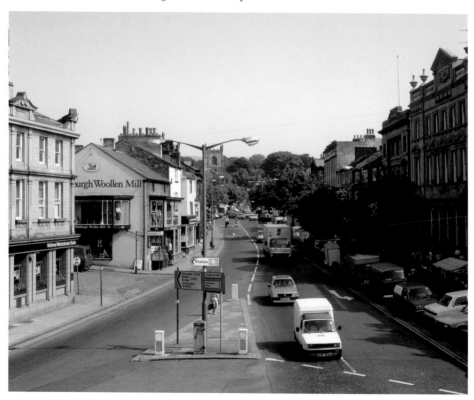

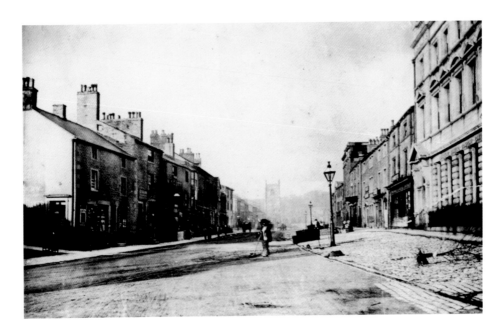

Skipton's Lime Trees

On 27 April 1897, the council decided to commemorate the diamond jubilee of Queen Victoria by planting the High Street with trees. Mr George Harrison Mason, who founded the well-known firm of G. H. Mason & Sons, was the chairman of the committee responsible for making the arrangements. The lime trees arrived from Carlisle on 9 November 1897 and planting began the following day. Here is a tree lying on the stone setts awaiting planting. Here is the same view in 1982, and according to the church clock, it is 12.10. The trees are eighty-five years old and look fantastic, even today in 2009.

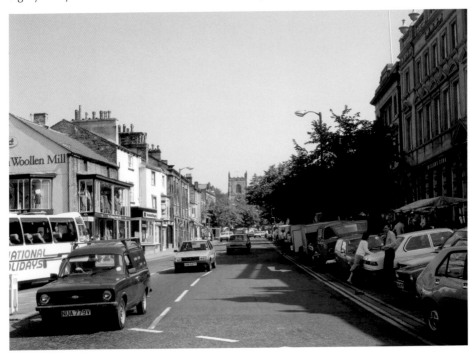

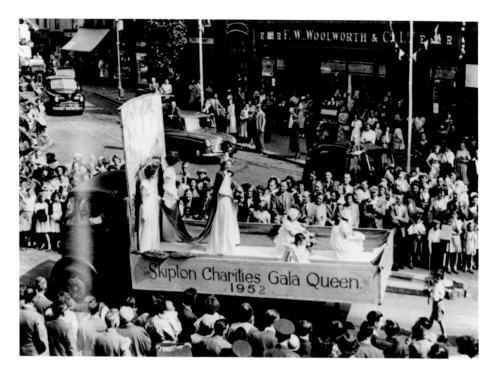

Woolworths and Ponden Mill

Another picture by George Prochok of the 1952 Skipton Charities Gala Queen. F. W. Woolworth & Co. Ltd was very prominent in Skipton then. This recent picture shows Woolworths in decline and Ponden Mill about to close.

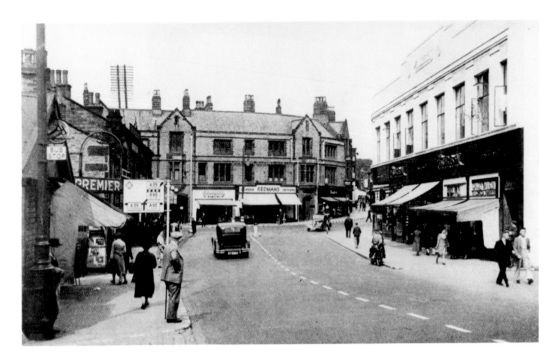

Ship Corner

A good view of Ship Corner, the way into the High Street and Burton's building on the right. The modern photograph shows a very similar scene but Greenwoods is now Dalesox and Oxfam has replaced the popular Redman's grocers shop. Note the Premier Cinema which was one of three in Skipton.

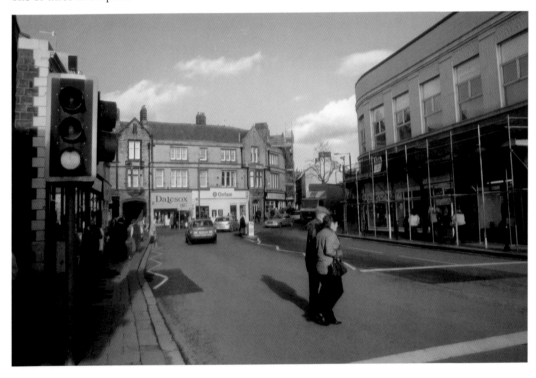

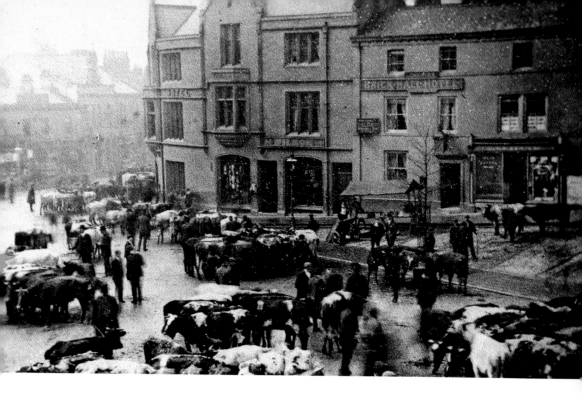

The Cattle Fair

Here we see the cattle fair spilling out of Caroline Square into the junction of Swadford Street and Keighley Road. My surgery was above Wilson's shop, next door to the Brick Hall Inn. Next door is the Ship Hotel, which replaced an older building which we will see later. This up-to-date view was taken at street level, as I was not given permission to go to a similar position in High Street House.

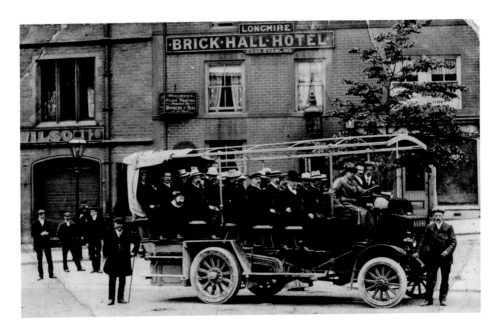

The Brick Hall Hotel

This is a very sharp picture of a charabanc about to leave the Brick Hall Hotel with a group of well-dressed passengers. In those days — in this case 1906 — people dressed up for special occasions. The picture was given to me by Carol Montgomery and copied by her husband Gary who has improved it so that we can read the signs. It was handed down from her grandfather Joseph Raw. Wagonettes are advertised, including picnic parties. Note saddler Wilsons, my old surgery window and two good gas lamps. The pub is now called the Woolly Sheep and Dollands are next door. This is the first charabanc I have seen with a cover.

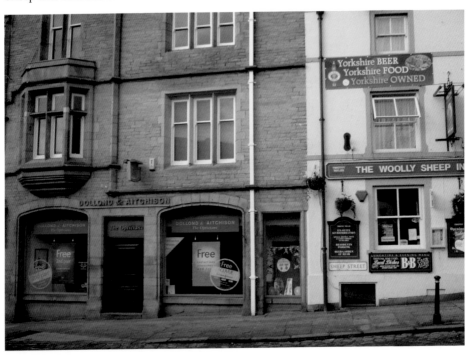

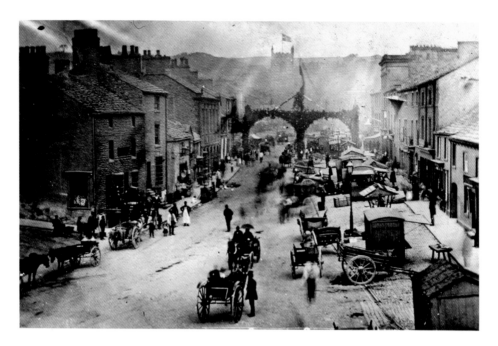

Skipton Show, 1870

The earliest known photograph of Skipton shows the High Street on the occasion of the Skipton Show in 1870, the annual exhibition of the Craven Agricultural Show, which was held from 1855 to 1929. The Midland Bank, built in 1888, can be seen on the right, but the trees planted in 1897 are not yet there. Note the two footpaths across the unmade road, necessary on Fair Day when all the cattle were standing about. Scott, the tub-maker, has a shop on the left and was here from 1822 to 1884, so this helps to date the picture. The coloured postcard is almost thirty years later. On the right is the Midland Bank, built in 1888.

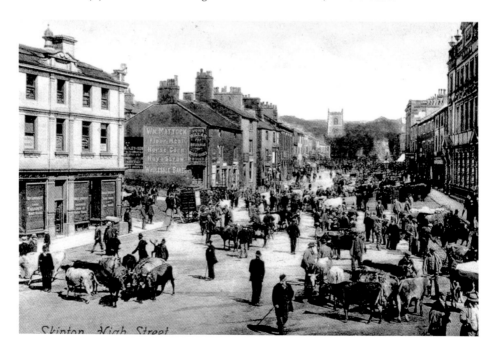

Skipton High Street

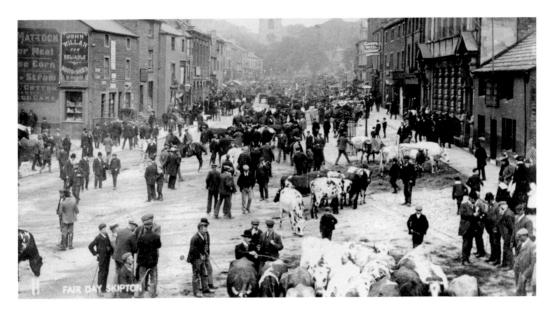

Fair Day
This is the scene on Fair Day after 1888 when the Midland Bank was opened and before 1908 when the Wheatsheaf Inn next to the bank closed its doors. The later picture was taken in 1982.

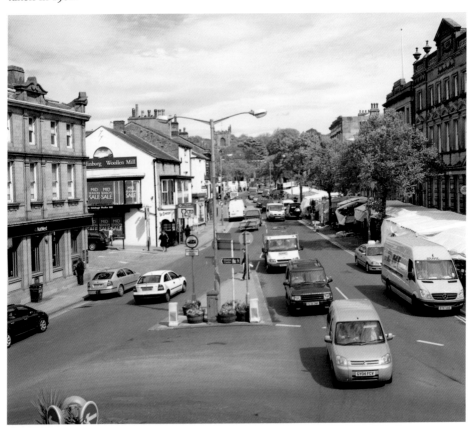

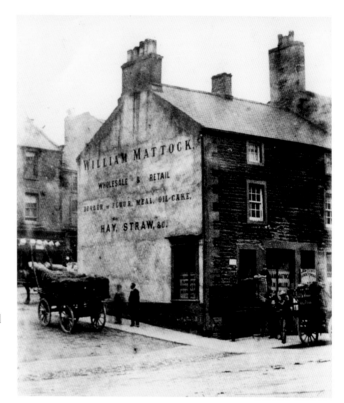

No. 86 Sheep Street
Standing next to Sheep
Street, over the years, No.
86 has been occupied by
various family-run businesses.
Various firms have used the
side to advertise, such as
William Mattock, Clayton seed
merchants and George Leatt.
Now the building is occupied
by the Edinburgh Woollen
Mill and down the steps is Le
Caveau restaurant.

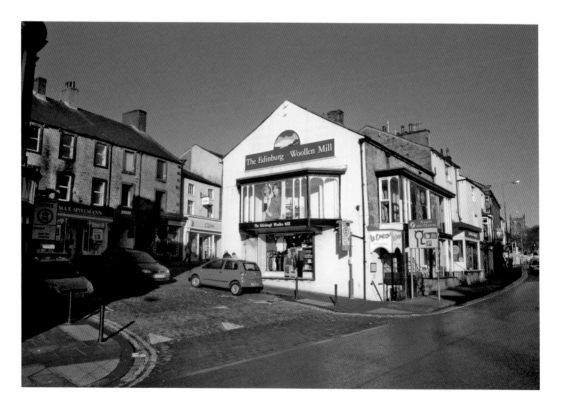

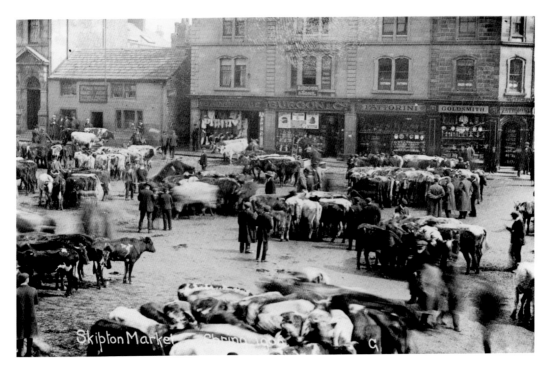

The Cattle Fair Viewed From Sheep Street Hill

Fattorini, the goldsmith, is shown here, and this became known as Fattorini's corner. The Wheatsheaf Inn is still there and closed in 1908. The Halifax Building Society is on the site of the Wheatsheaf Inn.

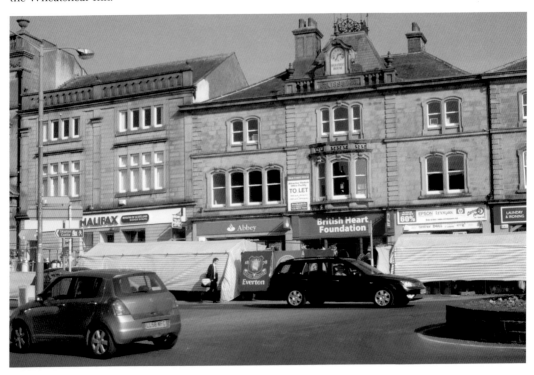

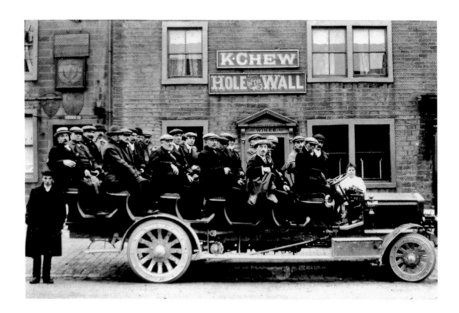

The Hole in the Wall

The Hole in the Wall pub closed about the same time as S and B Fruit Ltd; a great loss really, because both were good for the town. The new owners made an effort with the new frontage by continuing the arches to adjoin the one over Kendalls Yard. Compare the town at different times of the year. The chimneys were removed. The shop closed recently.

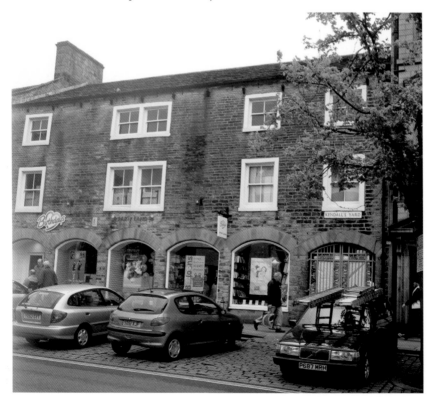

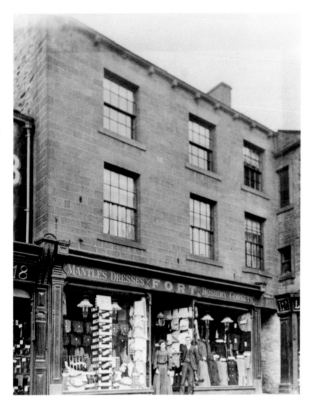

Forts, Sheep Street

Pictured is Forts draper's, Sheep Street, in 1905. Arthur, then eighteen, had just left Ermysted's to join his mother and father in the family business. Due to illness, the shop was sold to Mr Atkinson of Leeds in 1947. It continued as a ladies' outfitters and then became Greenwoods men's outfitters, but at present, the shop is empty. All of these shops in Sheep Street are good stone buildings.

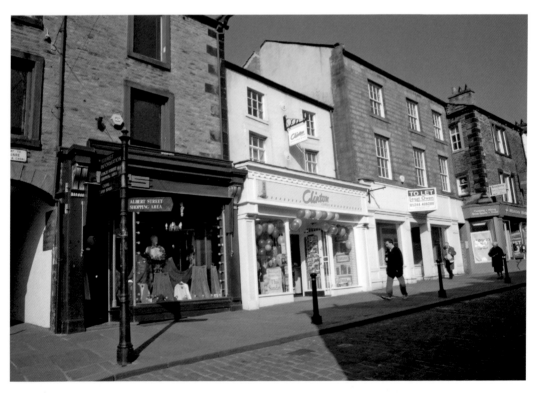

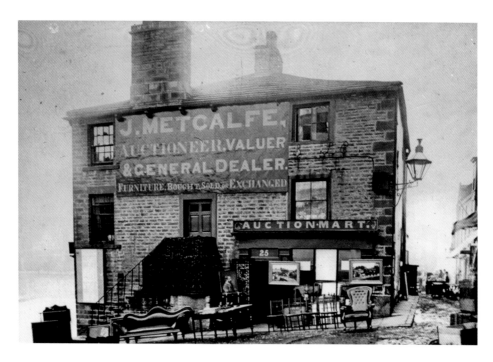

Sheep Street Hill

John Metcalfe's furniture shop on Sheep Street Hill was demolished in 1895 to make way for the Exchange Buildings, now occupied by Natwest Bank. Temperance speakers used to address the inhabitants from the top of the steps. Pictured below is the same scene today.

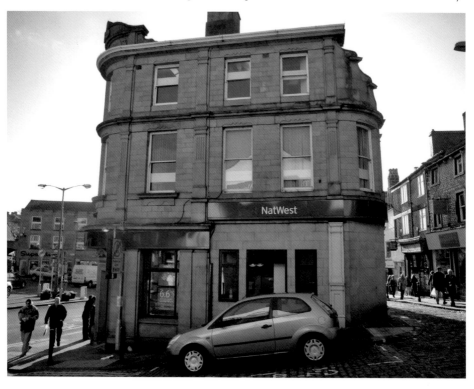

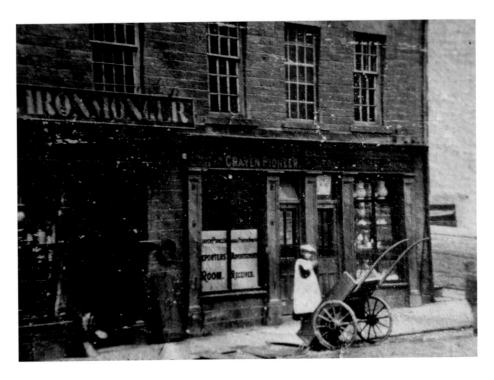

Middle Row

The lower section of Middle Row is shown here in about 1875. The two shops were occupied by Andrew the ironmonger and the Craven Pioneer, known as Staffordshire House. The building which replaced this was Exchange Building and is now Natwest Bank.

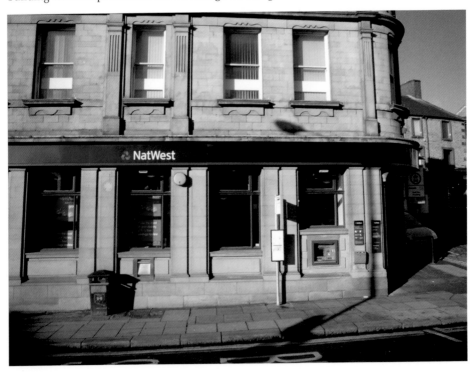

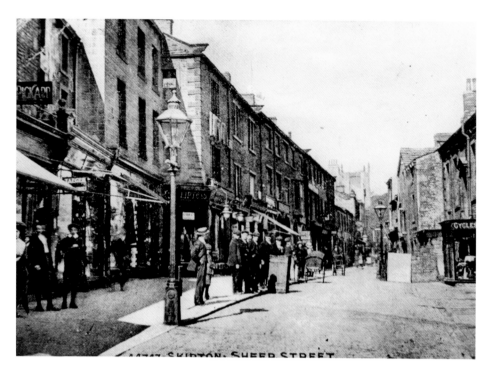

Sheep Street Before the First World War

Some fine shop frontages to be seen in the old photograph above. Below is Sheep Street photographed on an early morning in 2009.

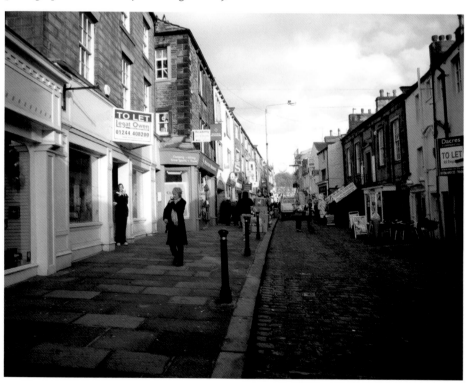

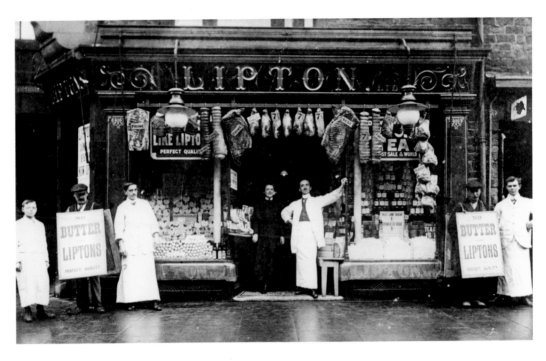

Lipton the Grocer
Lipton's shop displays a mouth-watering selection of fare in an era long before the supermarket. The placards read, 'No butter like Lipton's: Perfect Quality.' This shop is now an outdoor centre.

The Waterfalls' Stationery Shop

Sidney and Arnold Waterfall had this shop when we came to Skipton in 1953. They were stationers, but Arnold dealt in stamps and Sidney maps, so the place was busy with schoolboys and hikers. They had their headboard removed for renovation and discovered this one — a previous stationer's. As you see, it is now W. H. Smith and serves the town very well.

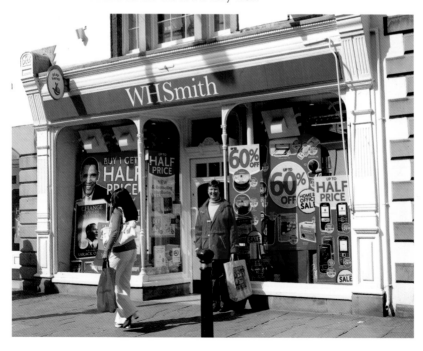

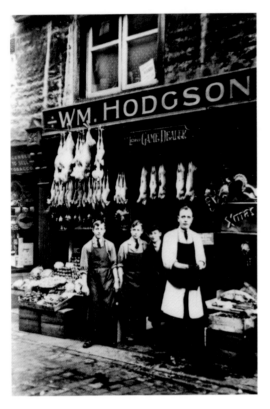

Hodgson's Shop, Sheep Street
W. M. Hodgson was in this shop in Sheep
Street when we came to Skipton in 1953.
They were well known for their quality.
One day, I went in the shop and Mr
Hodgson senior cracked a walnut with one
hand and said, 'All the way from Sorrento,
Mr Ellwood, best quality, thin shells and
full of walnut'. Tog 24 performance clothing
store has the shop today.

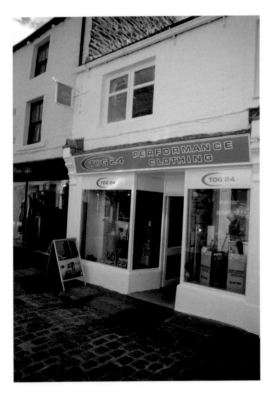

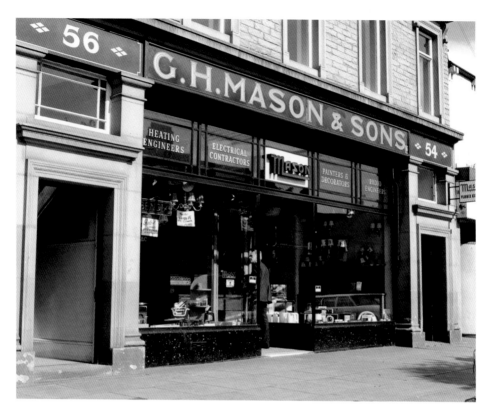

G. H. Mason & Sons

Having moved here from smaller premises, when G. H. Mason & Sons eventually closed, they left first-class premises behind. The building was ideal for well-known Boots Pharmacy to move into.

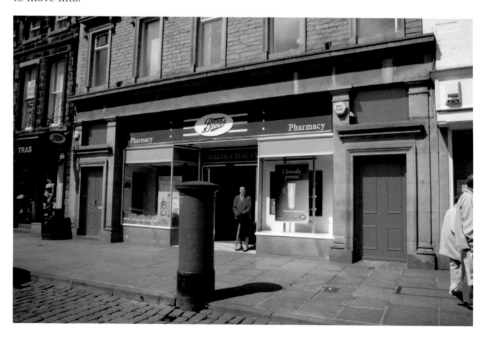

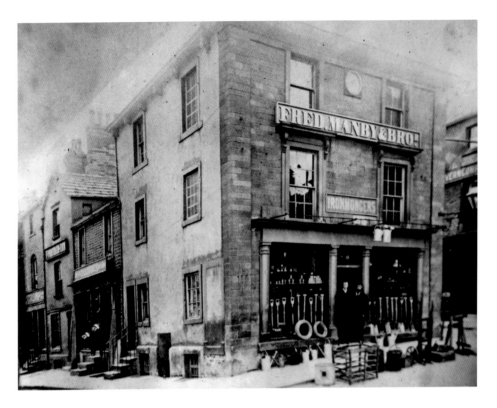

Fred Manby and Bro.

Fred Manby and Bro. was established in 1817. This picture was in my first book of Skipton in 1975 and was described as the oldest family business in the High Street. Note the Fountain Inn along to the left. A beautiful ladies' dress shop is here now called Phase Eight.

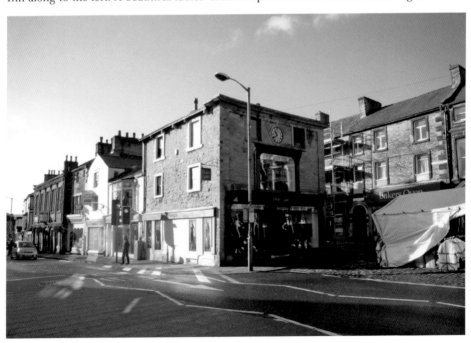

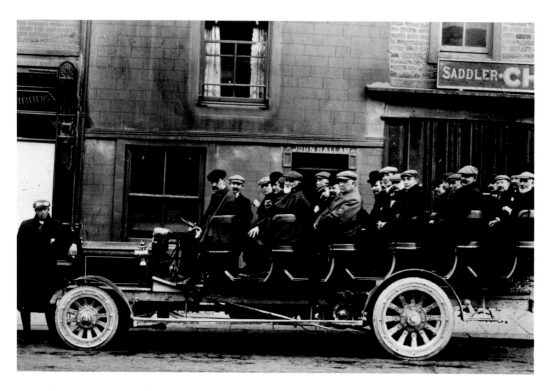

The Fountain, Middle Row

Like most of my pub photographs, there is a charabanc trip about to set off, and the Fountain in Middle Row, pictured above, is no exception. Below is the Fountain as it is now.

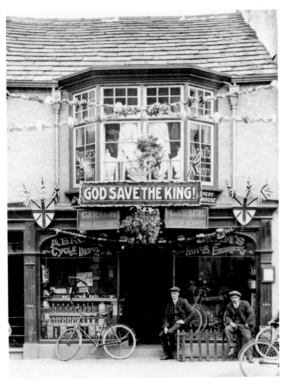

Mr Abram's Cycle Shop

This is Mr Abram's cycle shop in 1910, above which was a ladies shop selling jackets, blouses and hosiery. Both chaps are having a smoke. Note the decorations for the coronation of George V.

The shop is pictured below as it is today. For many years the popular hairdresser Ronnie Crossland, from Cracoe, had the room with the bay window.

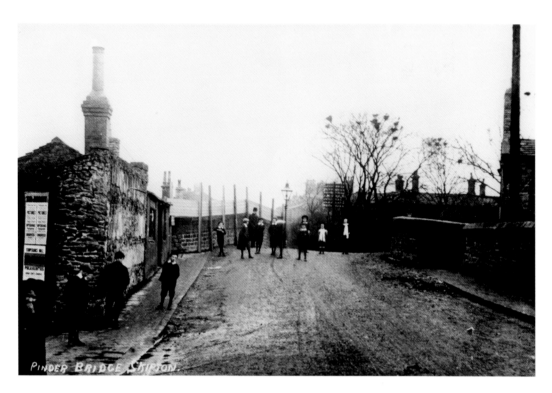

Pinder Bridge

The visitor to Skipton approaching the town from the south-east along the Aire Valley in about 1908 would have to cross old Pinder Bridge, which took the traffic over the Leeds and Liverpool canal. The old bridge was demolished, and when the new one was completed, it was tested on 9 November 1910. Three steam rollers and a traction engine were driven over it in both directions. Note the elegant street lamp on the south side of the bridge.

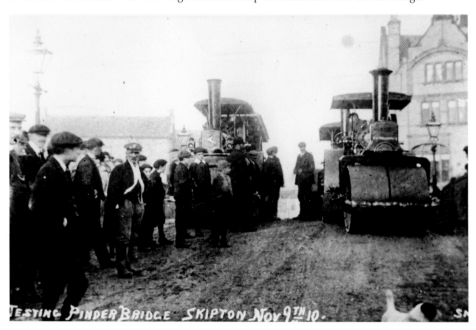

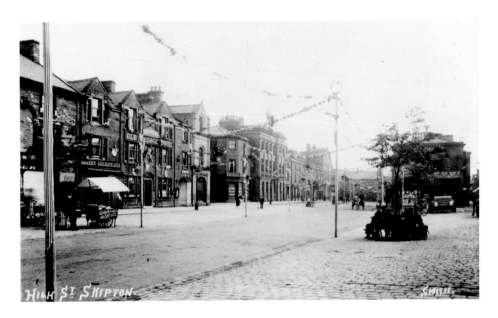

The Old George

Ambler, Robert Hurst and Co. and the Old George have now been swallowed up by Rackhams. A mowing machine on the left shows agricultural merchants are still there. George Metcalfe's 'High Class Ices' look inviting. In 1953 I often went for lunch to the Old George where there was waitress service in nice uniform. In the new photograph the seat round the tree is missing, but note how well the tree it has grown.

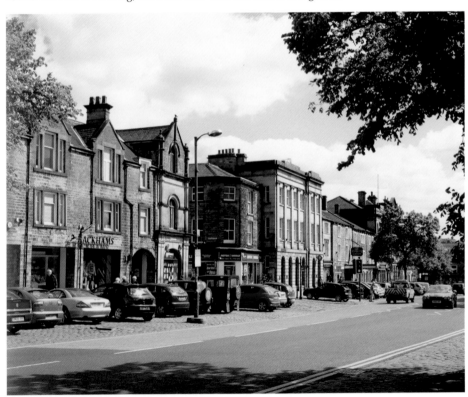

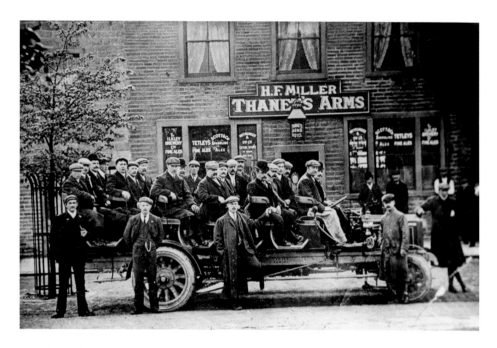

The Thanet's Arms

Pictured above is a pub trip from the Thanet's Arms. When Kath and I came to Skipton in 1953 this was Snowden's toy shop but it is now an outlet store. The last landlord was Mr H. F. Miller, and the last drinks at the Thanet's Arms were served on 23 December 1908. I wish some of these charabancs had been preserved.

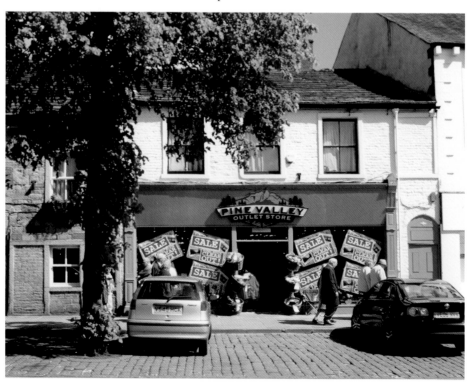

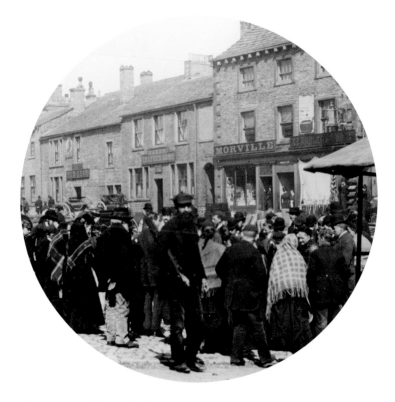

The Thanet's Arms and the Red Lion
The Red Lion and the Thanet's Arms can be seen in this Fair Day scene. Shawls are popular and one man might be wearing original 'mole skins'. The buildings look the same and this is a picture of Skipton where the upper parts of the buildings have hardly altered.

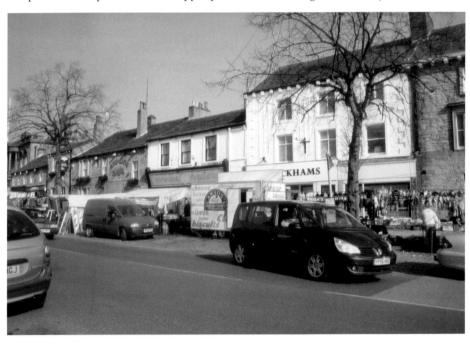

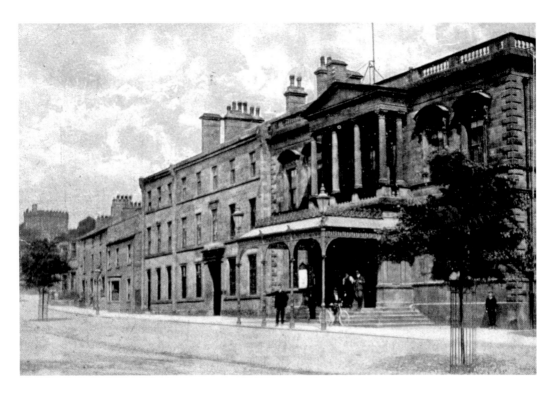

Skipton Town Hall

I include this picture to show the cast iron canopy at the entrance to the town hall, which was removed in the early 1950s. The cottages shown here were demolished to make way for the much-criticised health centre. Note the health centre, the continual stream of cars down the Bailey and the trees at their best in May 2009.

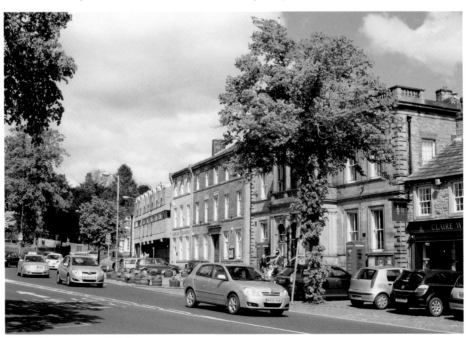

The King's Arms — Demolished

This public house was demolished to make way for a modern building. I remember calling in to look for a place to stay when I came to Skipton in 1953. I settled for the Brick Hall, now the Woolly Sheep, and was well cared for by Mrs Burke and family. Kath and I still enjoy meeting daughter Norah in town. The demolition opened up a good view through to Water Street.

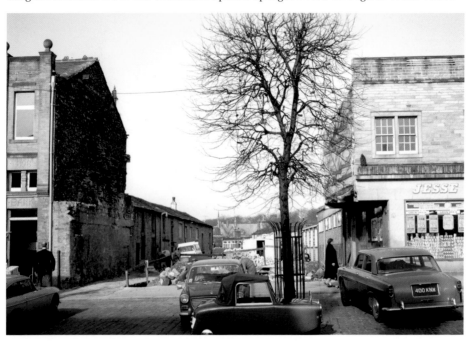

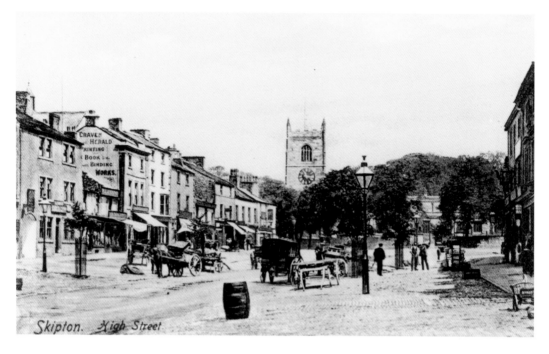

Skipton High Street

This photograph, taken at 11.15 a.m., shows quite a busy High Street. The gas lamps and the young trees, which were planted in 1897, indicate that this picture was taken *c.* 1900. A few old implements can be seen near to Agar, agricultural dealers. Craven Herald, Printing, Book and Binding works are clearly seen. The trees, now 112 years old, look good this spring of 2009.

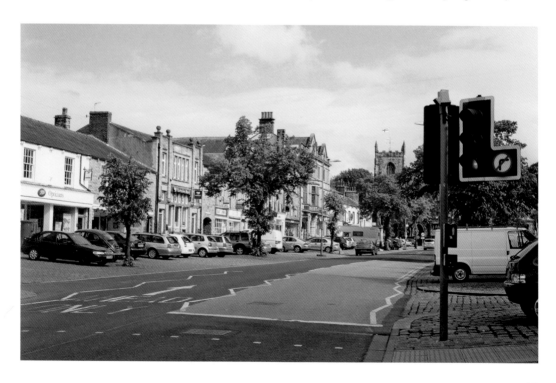

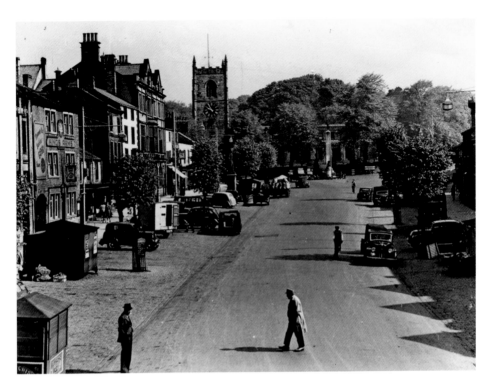

The King's Arms

Here is a picture that was perhaps taken soon after the Second World War — note the motorcars. I have included it because it shows a good view of the King's Arms, which is no longer with us. The old chap could not walk over the street in such a leisurely way now.

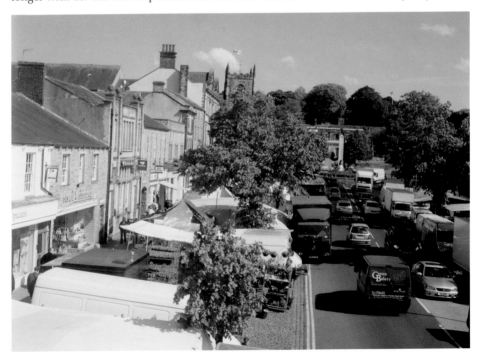

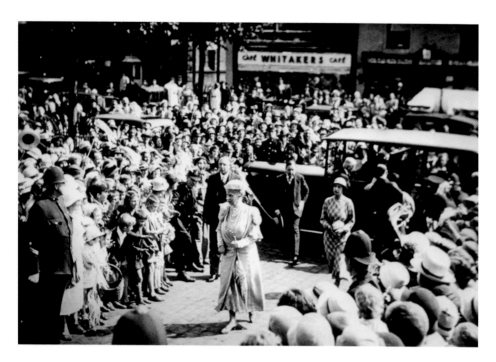

Laycock's Antique Shop on the High Street

Queen Mary had a great love of antiques and whenever she stayed at Harewood House, the home of the Princess Royal, she enjoyed visiting the most important dealers in the vicinity. Mr Laycock had a tremendous reputation in the world of antiques, as shown by the visit of Queen Mary to his shop on the High Street about 1930. Queen Mary alighted here in front of Laycock's shop. Claire Whitaker now runs what was then Whitaker's café.

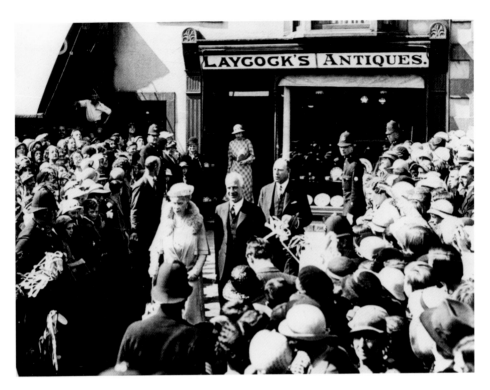

Laycock's Antique Shop on the High Street (Continued)
Here is Queen Mary coming out of Laycock's. 'Next' now occupy this space next to Craven
College entrance and library building. I had my eye on another building, but Tom Drake
told me this was the correct one.

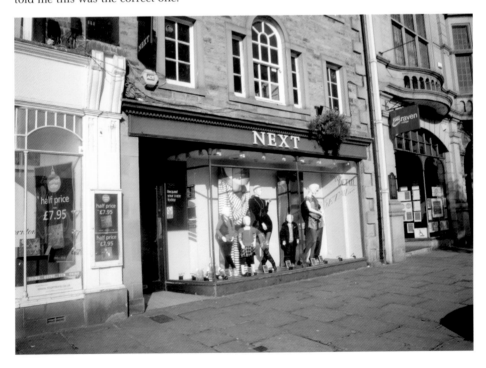

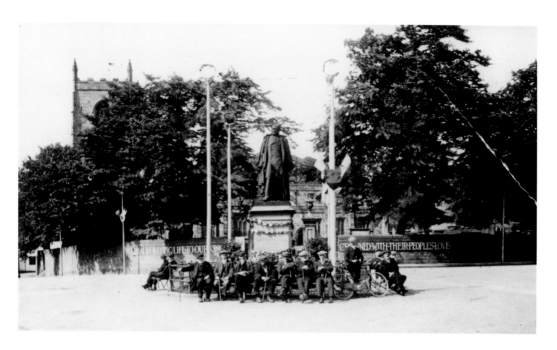

Skipton War Memorial

Shown here is Sir Mathew Wilson and the seats are occupied by older members of the community, perhaps a local 'parliament'. The photographer is Smith, a very prolific man with a camera. His daughter lived in Queen Street and she loaned me quite a lot of his photographs of the town. The banner is there because of the forthcoming coronation in 1911. The statue was moved in 1921 by B. B. Kirk, builder and contractor of Waller Hill, to a position in front of the library to make way for the new cenotaph.

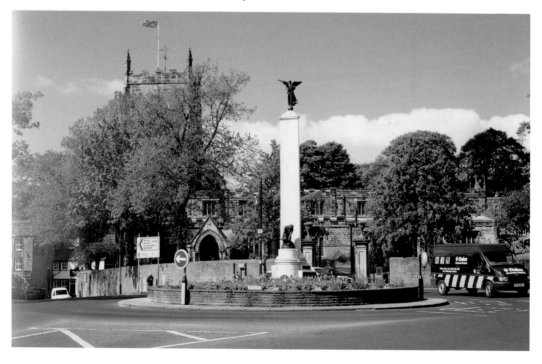

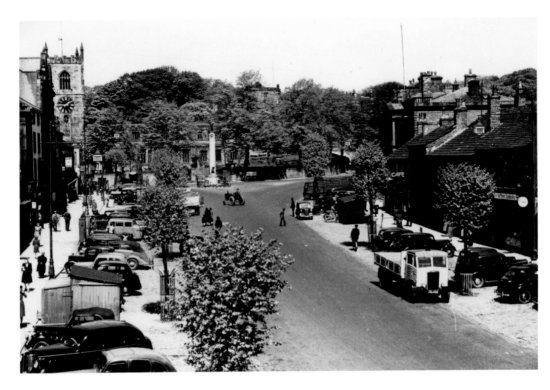

Skipton High Street
This is a picture I couldn't resist including as it shows a variety of cars owned by local people. There is also an old tractor up the street. The trees are the best part of this picture and were photographed in spring 2009.

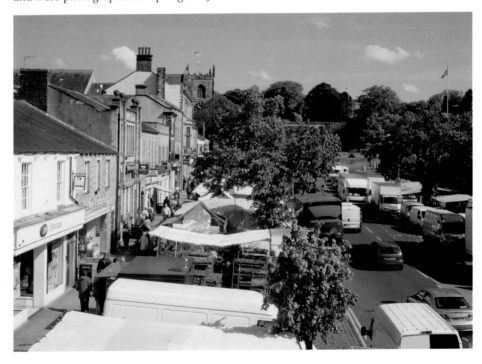

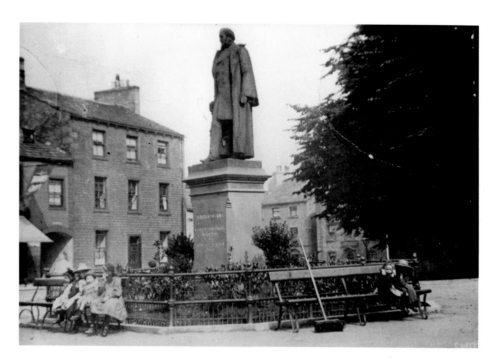

The Statue of Sir Mathew Wilson

Outside the public library, the statue of Skipton's first M.P., Sir Mathew Wilson of Eshton Hall, which was unveiled by the Marquis of Ripon in 1888, can be seen. It was unusual then for a statue to be erected to anyone in his own lifetime, as happened in this case. The house seen in the background (now Goldie's) was the home and surgery of Dr Forsyth Wilson. It was also the birthplace of his son Charles Mac Moran Wilson who was to become Lord Moran, Sir Winston Churchill's personal physician.

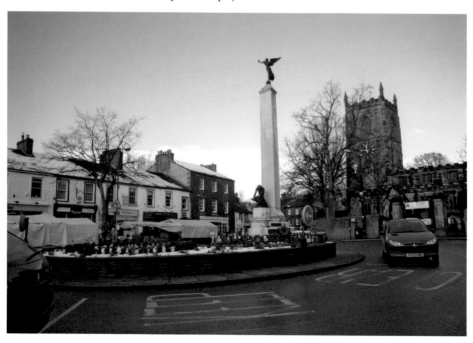

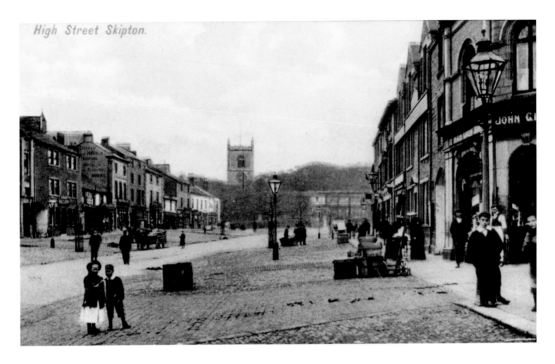

High Street Skipton.

The High Street

Pictured is a very pleasant scene of children in about 1900. People, of course, lived in Skipton and there were plenty of houses, many of which are now occupied by businesses. The trees are there, planted in 1897, but the library, which opened in 1910, has not yet been built. Note the Craven Herald printing works and the gas lamps, which add an elegant touch. The new photograph of the High Street was taken in March 2009.

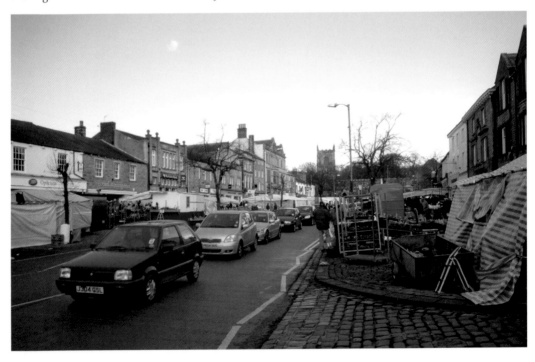

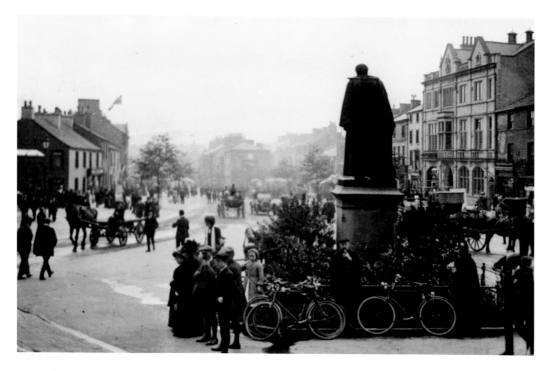

The Old Vicarage, High Street

The statue of Sir Mathew Wilson stands proudly at the top of the High Street and there is a lot of activity everywhere. I want to show the footpath from the vicarage, just out of picture, to the church. Here we can see, in the picture of spring 2009, the old vicarage this side of the town hall. The cenotaph is now on the site of the statue. Part of the footpath can still be seen near the tree.

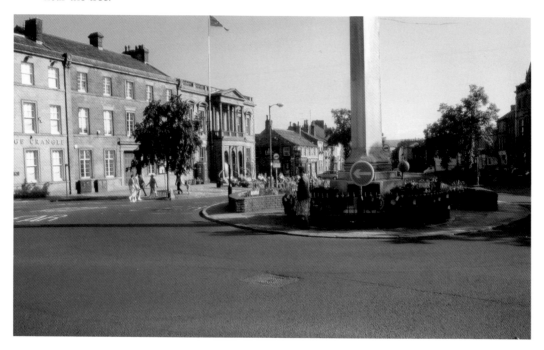

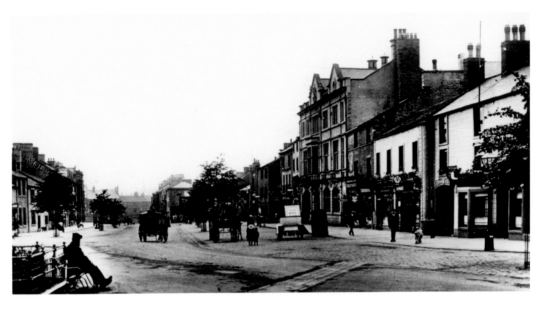

The Top of the High Street

In the above picture, the surround to the statue is on the left with an elderly gentleman sitting on a good viewing seat. Note the other footpath from the church over to the Black Horse and library. The same view is pictured below in 2009.

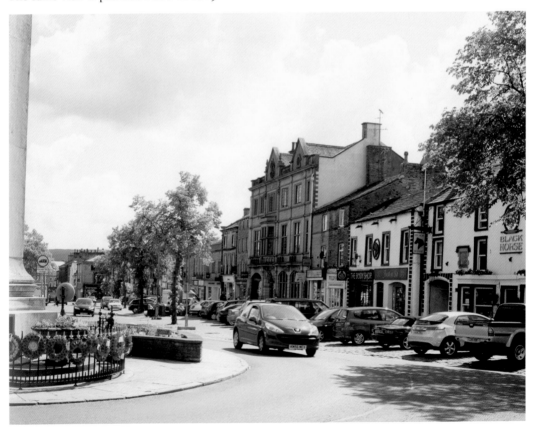

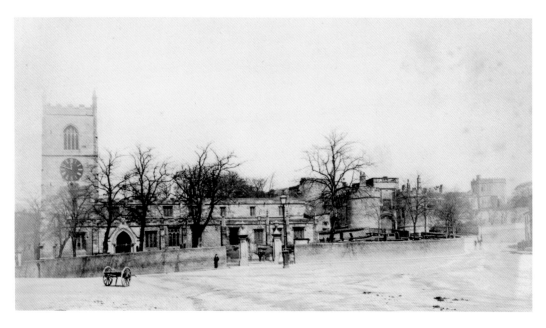

Skipton Church and Castle

Richard Fattorini found this beautiful early photograph of the church and castle, believed to have been taken *c.* 1873. The gas lamp christened 'Old Gormless' is there. The new photograph was taken in March 2009, with part of the market in view. Later, in full spring, the leaves obscure the church and castle.

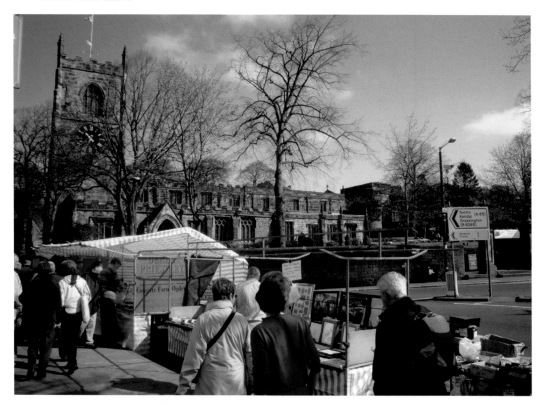

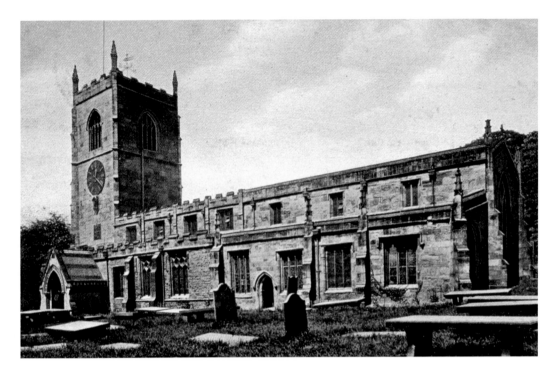

Holy Trinity Church

Pictured here is the Holy Trinity church with the tombstones in place. I think I remember them when we came to live in Skipton in 1953. The stones were removed and stacked behind the church. Below is a recent picture of the church.

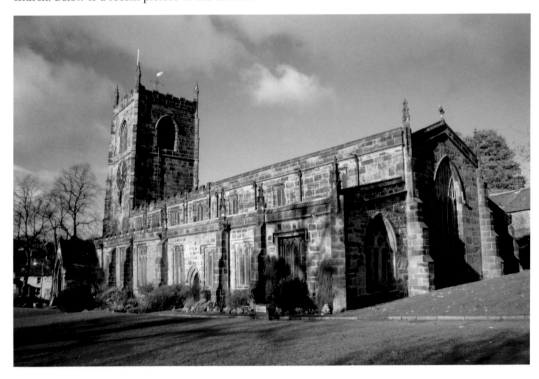

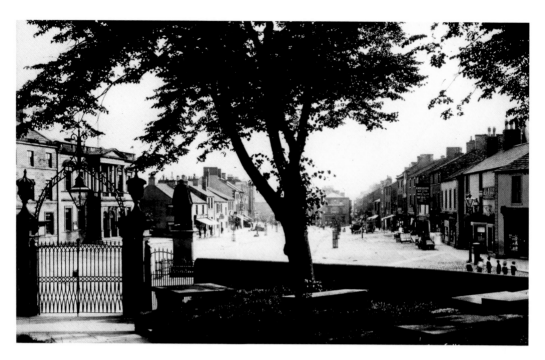

The Church Gate

Above is a very interesting picture that shows a beautiful gas lamp suspended from the church gate, and the tombs are also present in the churchyard. J. L. Kidd had the Black Horse Inn and a clear sign advertises the Excelsior Hair and Shaving Salon. My modern picture shows that the church gates have been redesigned — in memory of the popular Dr Fisher.

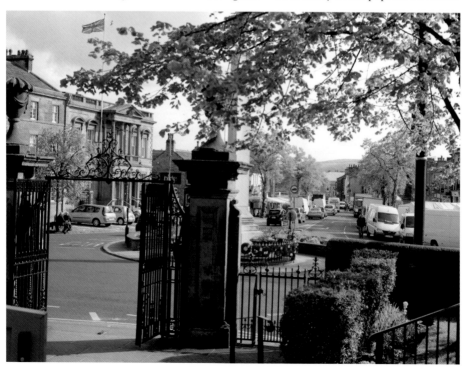

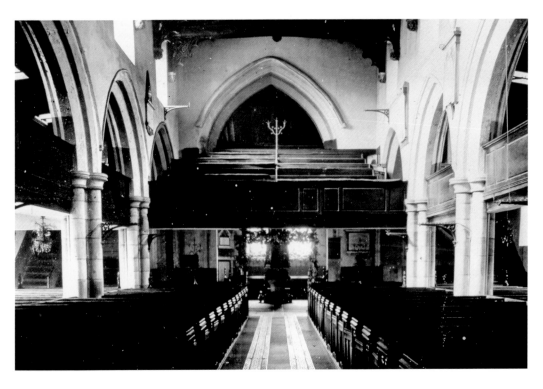

The Parish Church — Interior
Pictured is the interior of the church when galleries were in position. They were later removed and this is the scene today. Mr Hird used a Thornton-Pickard large plate camera to take this picture.

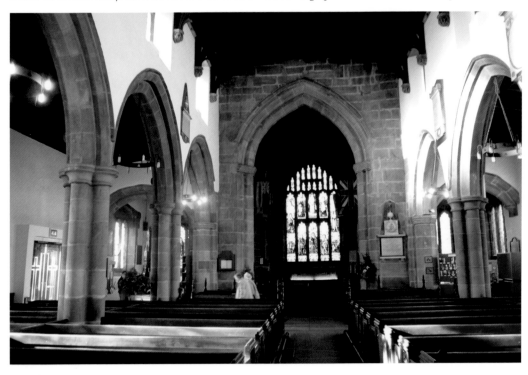

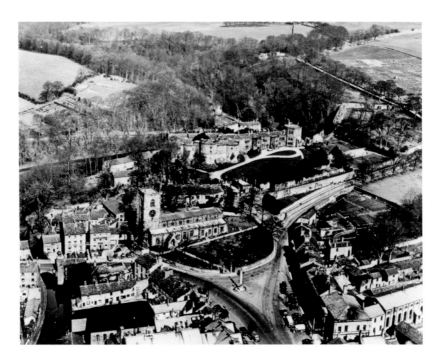

An Aerial View of Skipton

An aerial view of the top of the town, perhaps taken by C. H. Wood of Bradford in 1949, is paired with another aerial view taken by me in April 2004 on a flight from Blackpool. Note in particular the wall and lawn just above the church tower, a new improvement to the castle grounds.

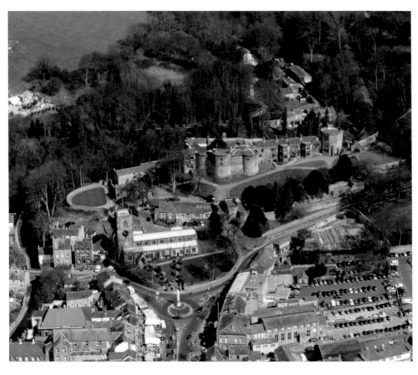

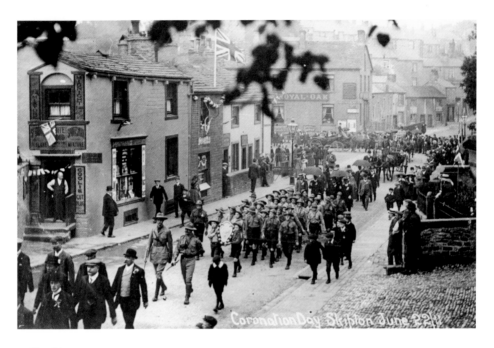

Mill Bridge

Above is the coronation procession crossing Mill Bridge to celebrate the coronation of George V in 1911. The Royal Oak and the Castle Inn are still here.

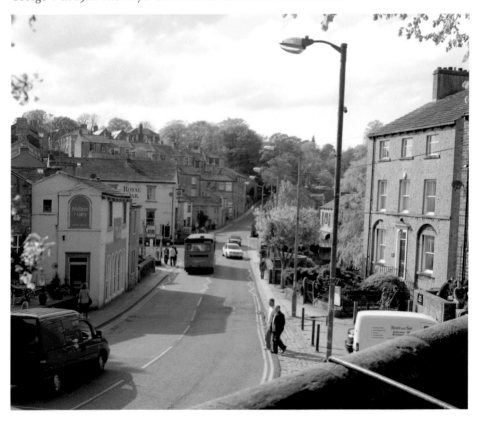

Springs Canal

An autumn scene next to the New Ship pub, photographed about twenty years ago. The path on the left is the way into Skipton woods, now managed by the Woodland Trust. Often missed by tourists, it leads to a wonderful area of Skipton. A small barge takes passengers up to the end of Springs Canal. On the right, a walled area prevented erosion. This area was full of trees, hence the mass of autumn leaves in the first picture.

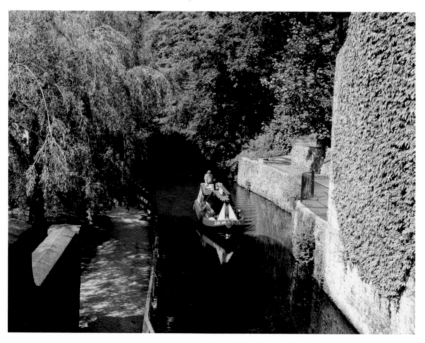

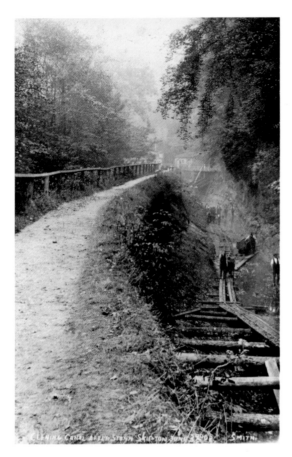

Rock Line

At this point, we divert along Springs Canal where there is some interesting industrial archaeology to be seen in the old photograph. The canal, which was opened about 1877, was a branch from the Leeds Liverpool to collect stone from the quarries near Embsay. Here the branch is being repaired after the disastrous flood of 1908. It is behind Skipton Castle. The modern photograph shows the canal in spring with a barge carrying visitors.

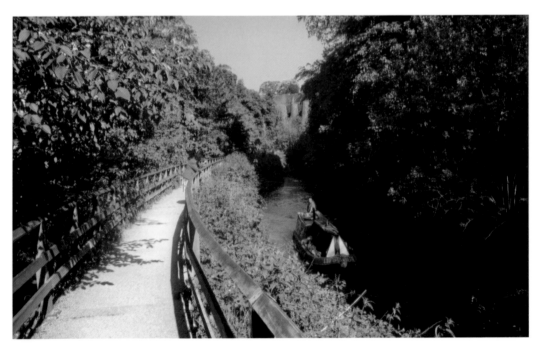

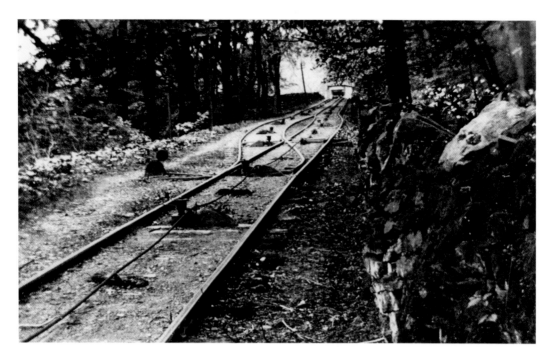

The Old Railway

Behind the trees above Kath lies this railway which allowed wagons to be lowered down to the chutes delivering stone into the barges. A full wagon hauled up the empties, hence the crossover. Steam tank engines brought the wagons a mile or so to the top of the incline. The railway is now completely overgrown except for the abutments that supported an earlier railway. Delivering stone at this height did not work because it damaged the chutes and barges dropping from that height.

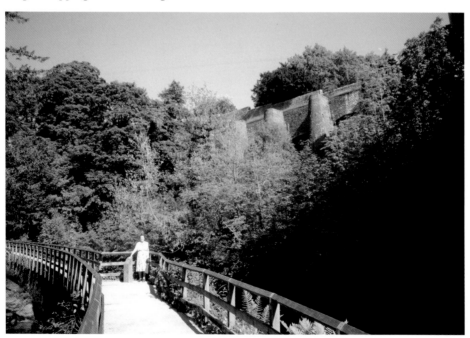

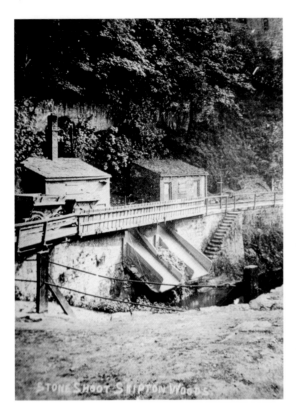

STONE SHOOT SKIPTON WOODS

The Canal End of Rock Line
A wagon can be seen on the left of the picture and this could deposit stone down to the barges without causing any damage. The chutes were still there but are now so overgrown that even the level area where the lines were is lost. The old line, supported by buttresses, was abandoned because the stone dropping from this height damaged the bottom the barges.

Skipton Castle and the Canal

The footpath crosses a bridge after leaving the end of the canal and emerges at the left of the cottage. Here we see Skipton Castle towering above the canal. There is another dam behind the cottage fed from the beck, which runs down next to the canal. Hedges and trees have grown, almost obscuring the cottage, but there is still a view of the castle.

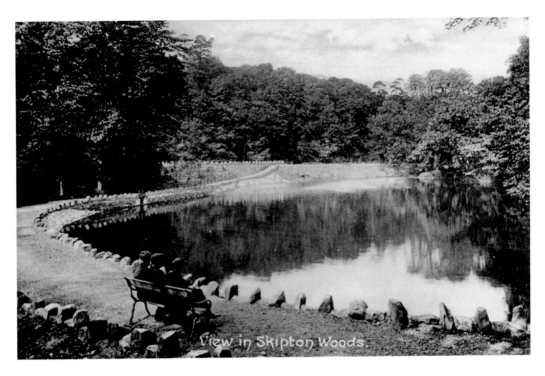

View in Skipton Woods.

The Round Dam

Here is the Round Dam, which was a haven of rest for the people of Skipton — many of whom worked in the mills. This is a scene in the twenties or thirties and the whole place is immaculate. Beyond this are the Long Dam and the Skipton Bypass. A heron was nesting in the trees on the far side of the pool.

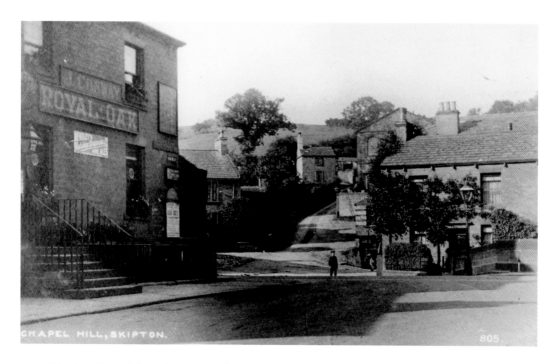

The Junction of Grassington Road and Water Street

When the Royal Oak was built, the road in front was much lower and the front door was underneath the steps. The canal branch was not there and the beck came over the road creating a ford and quite a steep hill on each side. More traffic can be seen in this picture and a stop sign which many people ignore. There is a good view of Chapel Hill in each picture and a favourite walk of ours when we came to Skipton. One can walk over the top down onto the old golf course lane and back down through the woods via the Long and Round Dam.

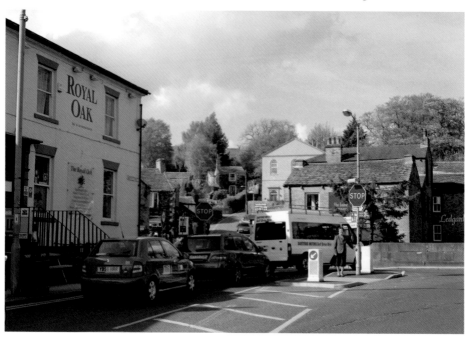

Old Cottages
Above is a view of the cottages, which were demolished in 1956. The building behind was owned by Craven Tenant Farmers and the top floor was used by Skipton Prize Brass Band.

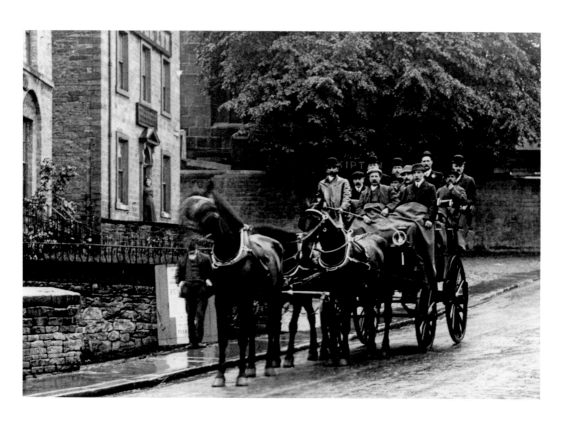

The Castle Inn
A fine view of a three-horse carriage — perhaps another pub trip from the Castle Inn. The scene today also shows the Castle Inn, which seems to always command sunny days when people can sit out.

Cottages on the Canal
The cottages near the canal and river were demolished in 1956. I can remember them. They made way for a beautiful 'sitting out' area between the river and canal. The tree on the left was planted by Mrs Walters who was a prominent member of the Civic Society and kept a sharp eye on the town.

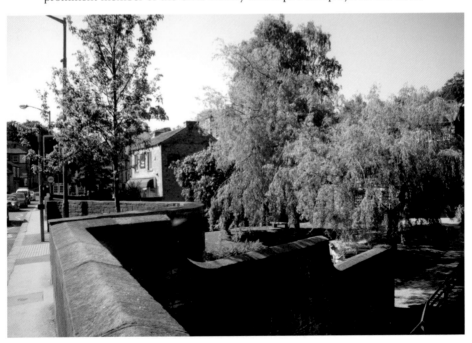

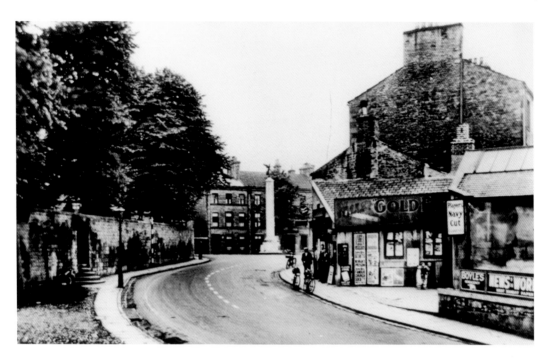

The Top of the High Street

Pictured above is a photograph from the 1920s showing up the hill into the top of the High Street. Plenty of 'ads' in the newsagent's make it look interesting. The side entrance into the churchyard is very architectural, and the trees in spring of 2009 are beautiful. The pot plants on the wall of the Italian restaurant finish off the picture. Tootsie has now closed and Bloemist the Dutch florist is now there.

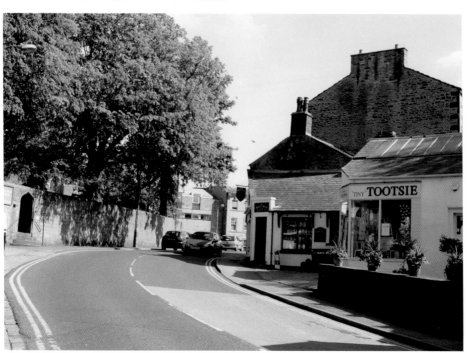

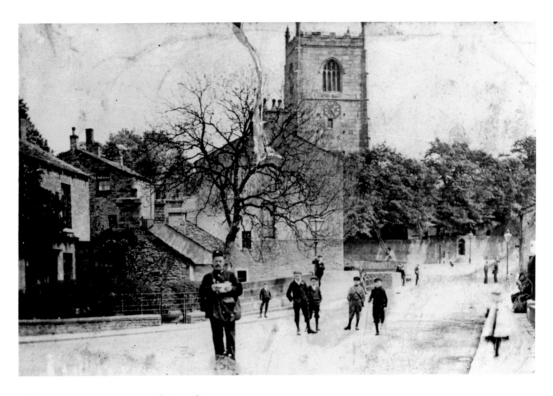

Skipton From Gargrave and Grassington

The north-western entrance to Skipton from Gargrave and Grassington in the early 1900s. The houses which can be seen behind the postman were demolished in 1956. Note the boy up the gas lamppost. A quiet scene as it is today. The crossing lights at 'go' are fairly new.

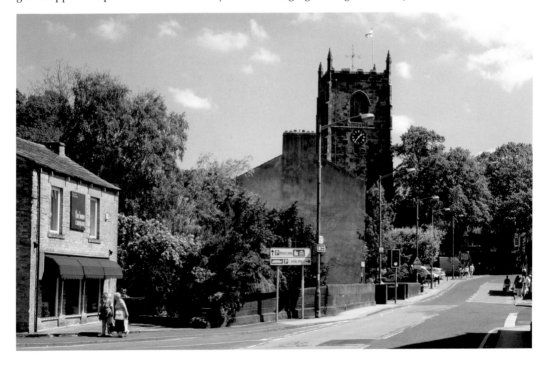

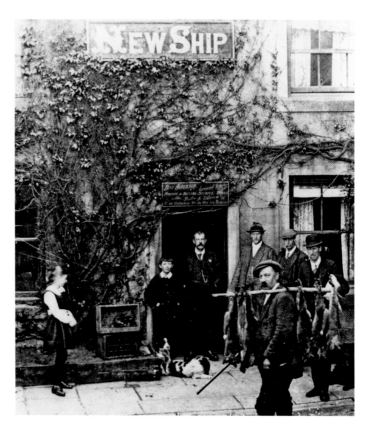

The New Ship Inn
Pictured is the New Ship
Inn, not far from the
top of the High Street.
Here in 1918 lived Fred
Alderson with his family.
Also in the picture is Tom
Clark, gamekeeper to
Skipton Castle, returning
from a foxhunt. Today
David Hill, estate agents,
occupies it.

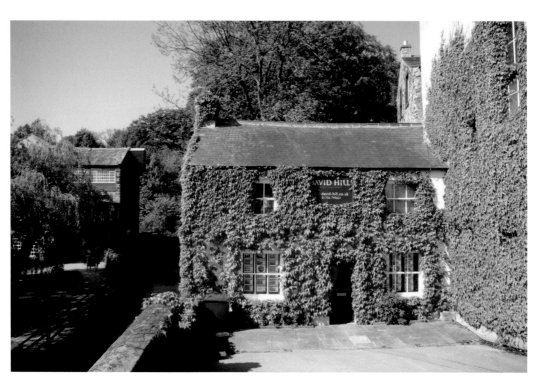

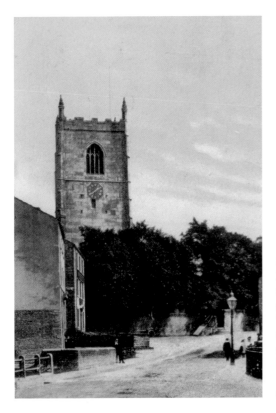

Skipton Parish Church (Holy Trinity)
Before the coming of the canal, which lies
under the bridge shown here, there was
a much steeper hill into the High Street.
The entrance to the New Ship Inn is down
a slope next to the people by the wall and
could have been standing on level ground
before the canal was here.

 The view today shows a constant stream
of traffic into the High Street.

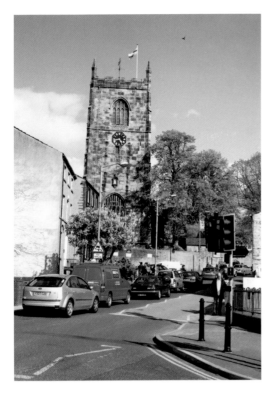

Jack Ward's Smithy
This is Jack Ward, the blacksmith, making a horseshoe at his smithy at the bottom of Raikes Road. Jack took over the business from his uncle H. Ellwood (no relation). I took this picture on my way to work in 1972. I wedged myself against the open door hinges and the exposure was a fifteenth of a second at f2.8. Now, it is the Wright Wine Shop, and the photograph was taken from the same position.

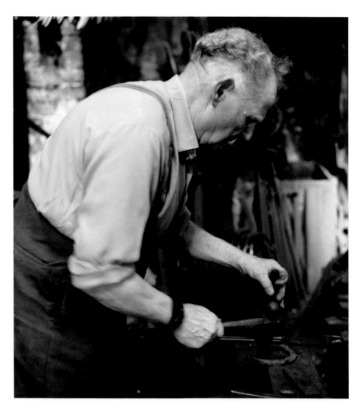

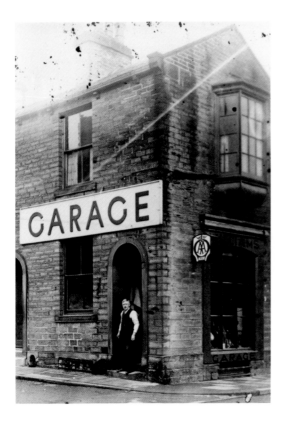

The Water Street Garage
Moving along Water Street was the garage at the corner of Victoria Terrace. Williams were coach builders but moved on with the times. I have one of their large brass nuts which were used to secure the wheels. The name is stamped or cast on the flat side. Below is the premises today.

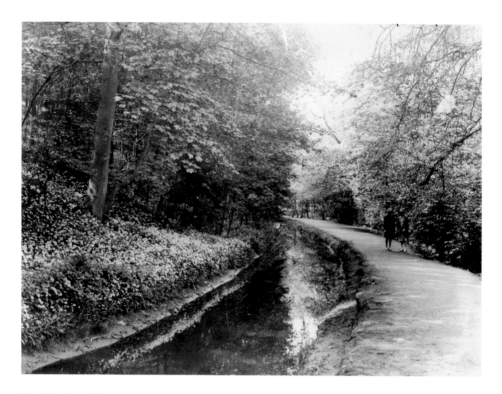

The Sandy Goit

This is called the Sandy Goit and it carries water from the dams higher up to the High Mill. It was dry for many years but is now running again, thanks to the Woodland Trust. Note two girls in 1930s-style hats on the footpath. The footpath leads on to the Round Dam; a lovely walk.

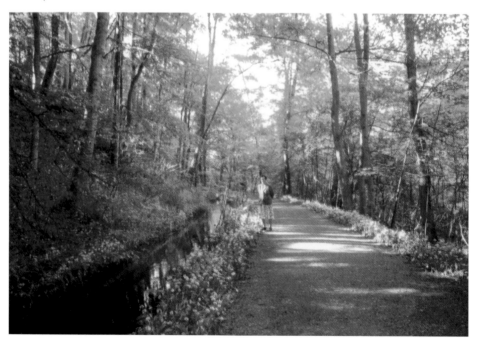

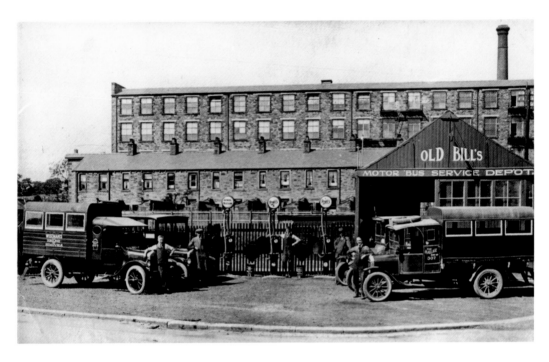

Old Bill's Motors

Approaching Skipton along Broughton Road one could see the garage of Old Bill's Motors. William Wiseman founded Old Bill's Bus Services and later opened a larger garage on the other side of the road. The modern photograph is taken as near as possible to the original site.

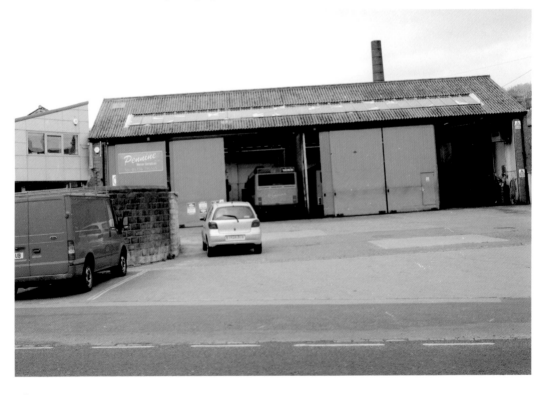

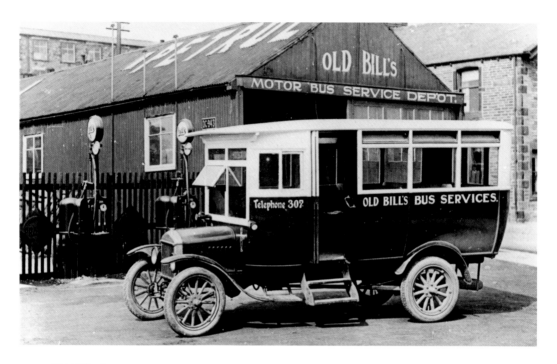

Old Bill's Garage

'Old Bill's' first garage is pictured here with his bus (I think it was a conversion from a car). An elderly man told me that if it stalled going up the Bailey, passengers had to give it a push! A modern-day local bus near the same site is shown below.

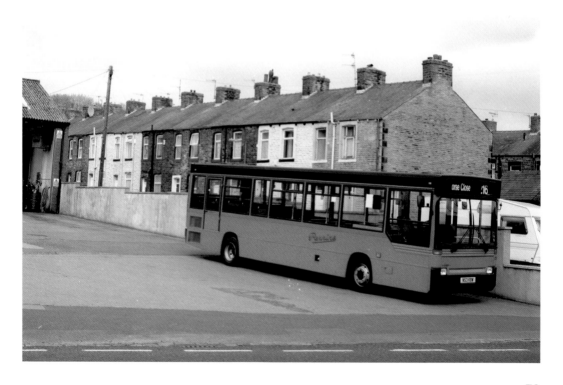

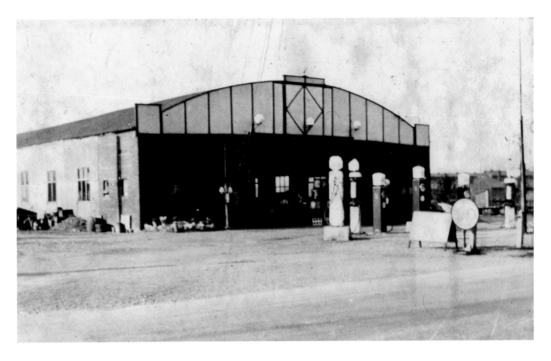

New 'Old Bill's' Garage

This was the new 'Old Bill' garage. 'Old Bill' (William Wiseman) was a character. I went along with William Foster, the solicitor, who had a noisy exhaust. Bill was sitting outside and before we could say anything he shouted, 'Scrap yard's round t'back!' I had a 1955 Ford Consul that had to be serviced every thousand miles. It cost 10s. Mr Wiseman came to have a chat and his way of indicating the on-going expenses was 'It's like paying till a bairn'. Eventually, not so long ago, the garage was demolished and was replaced by a shopping complex.

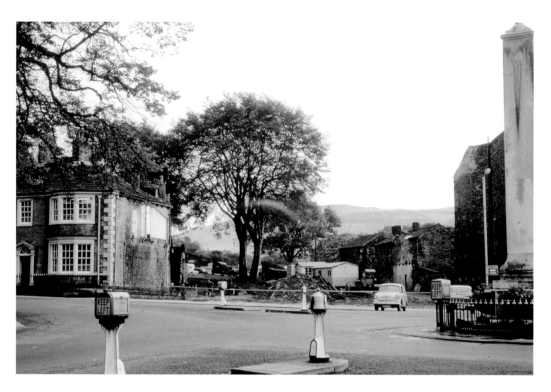

Another Bite Out of Skipton's Ancient High Street

The row of old cottages seen in the earlier photograph were demolished to make way for a new health centre. For a while there was a good view of Rombald's Moor. The cottages were demolished in September 1963 and building of the new centre began in October. It was completed in 1965 and is shown here.

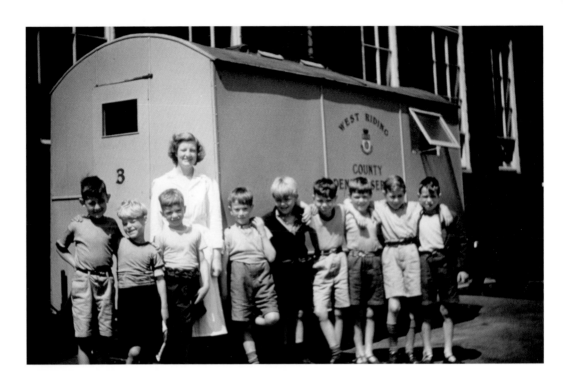

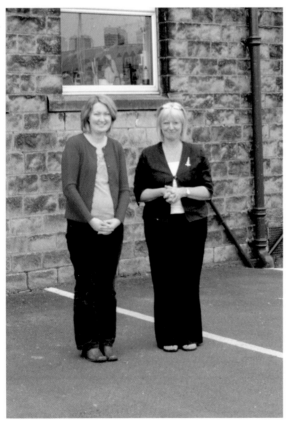

Ings School

In 1953, Ings School enjoyed a visit from the school dentist — me! The mobile surgery, a caravan, was scrapped many years ago, which was a shame because we took dentistry to the schools and no one was missed out. It saved parents a lot of trouble. We are not allowed to photograph children now so Mrs Pearson (head-teacher) and Mrs Jackson (parent support adviser) stood in the same spot. Roberta Cowley (Bobby) who was a patient aged eight at that time has named most of the boys in the old photograph.

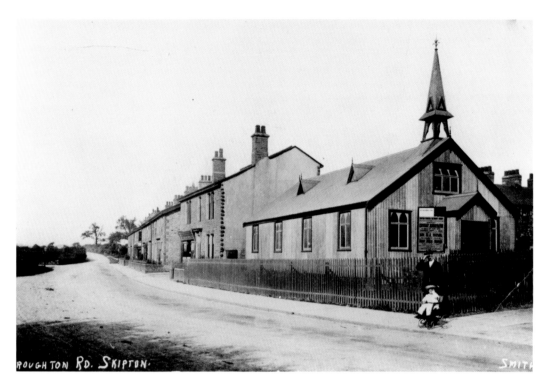

The Primitive Methodist Church

The first houses that would have been seen when travelling to Skipton are pictured along with the Primitive Methodist church, known as 't'old tin Tab'. It was erected in 1906 and is now a community centre. Here it is today and beyond is a Cantonese restaurant.

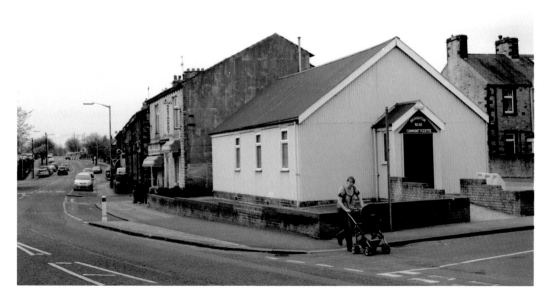

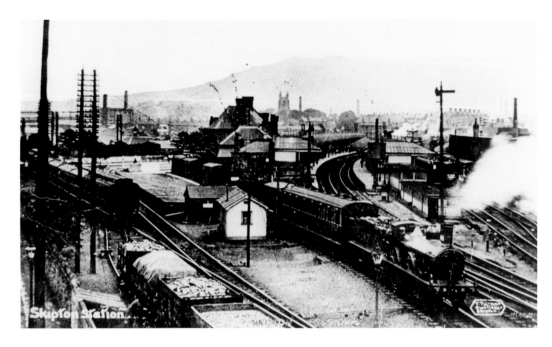

Skipton Railway Station

Here at Skipton railway station is a Midland Railway locomotive waiting in the 'Horse Dock'. Christ Church can be seen along with a few mill chimneys, most of which are now gone. In the '70s and '80s many steam 'specials' passed through Skipton. Here are a few, some of which made the front covers of railway magazines. The lower image shows Midland compound No. 1000 double-heading *Green Arrow* on trip from York to Carlisle, early 1982.

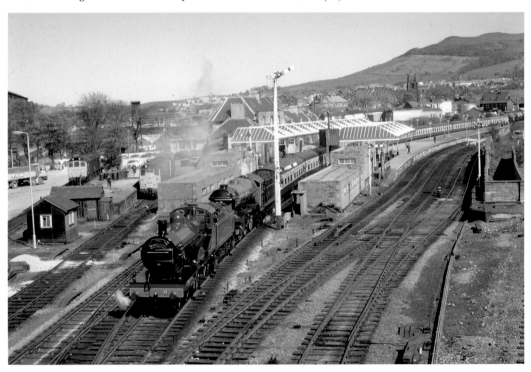

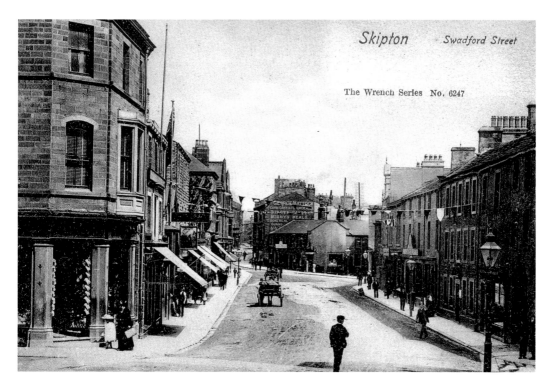

Swadford Street from Belmont Bridge

Here is an Edwardian scene that looks along Swadford Street from Belmont Bridge. Porri and Son was a well-known and useful 'pot' shop. Today it is a bright street. Some of the buildings on the right have been demolished and rebuilt twice.

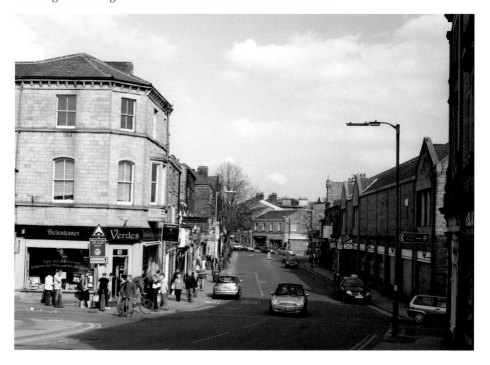

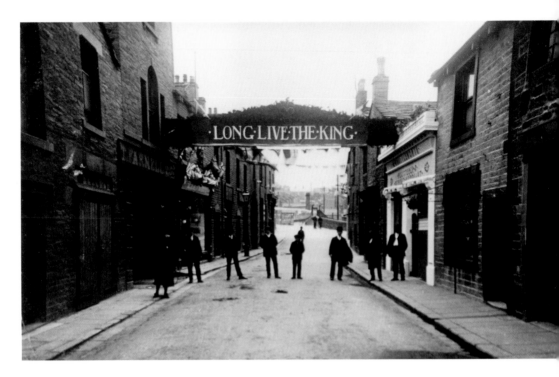

Coronation Arch, Coach Street

Just along Coach Street from Swadford Street was another arch in celebration of the coronation of George V in 1911. There are more nice shops in Coach Street now and more ways down to the canal. Nearby are a good stationer, a camera shop, eating places and a way up to the High Street.

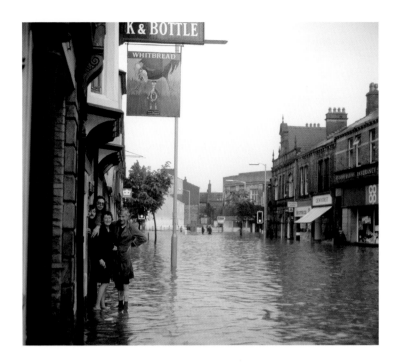

The Flood of 1979

This flood was quite devastating, and many cellars were flooded but most cars escaped. I was just a little late to film the landlord of the Cock & Bottle swim across the road and back. The right side of the road is now a taxi rank.

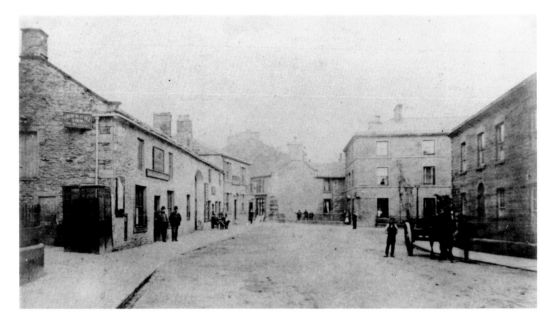

The Old Ship Inn

This is a very early photograph that shows the old Ship Inn on the left, demolished to make way for the New Ship Hotel, built in the late 1800s. The large house ahead was the dental surgery of Mr Hargreaves, demolished in order to widen Ship Corner. On the right is Christ Church vicarage, which is still there. The railings around it were removed but their position is still marked by stone setts. The building erected on the site of the old dentist's house was called Burton's Buildings.

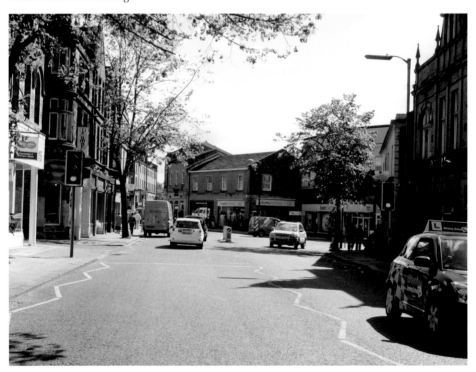

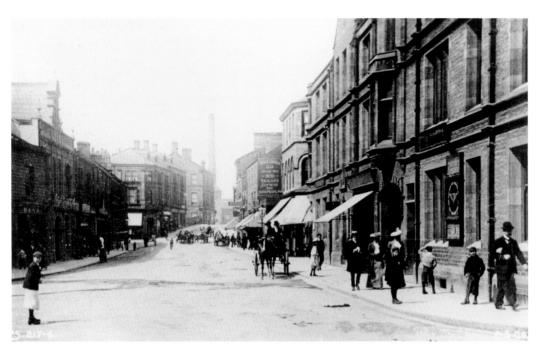

Swadford Street Looking West

The sign reads, 'Chadwick and Co. employ over 1000 tailors, cutters and workpeople.' Behind is a sign for Porri's, a shop selling china and kitchenware. The modern photograph was taken early spring, so the trees are not in leaf and we can see the shops.

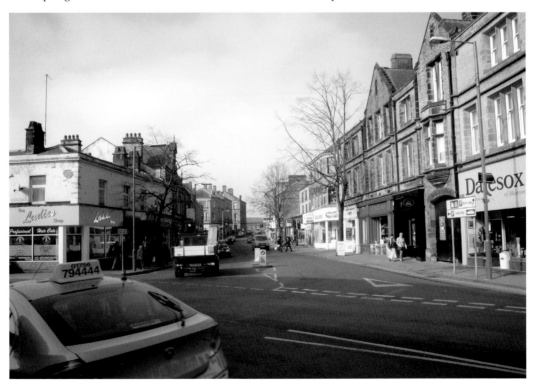

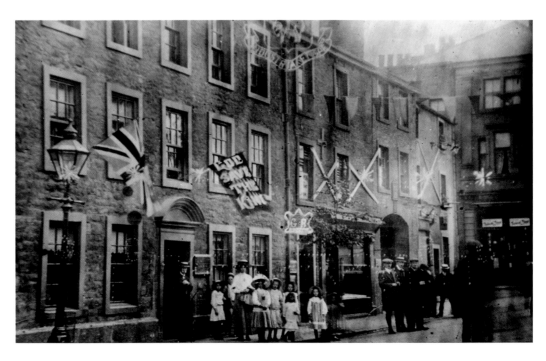

Swadforth House

This was the home and surgery of Mr Sloane, the dentist, seen here with his large family at the time of the coronation of George V in 1911. The rebuilt Co-op also houses the post office.

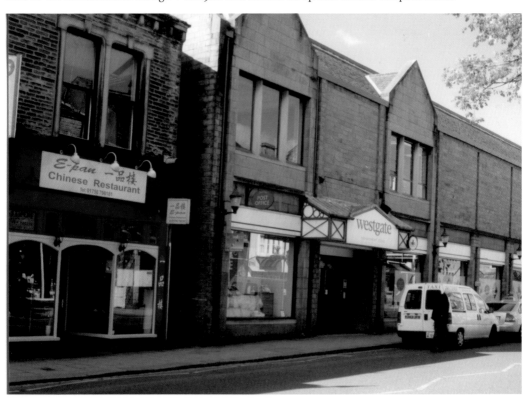

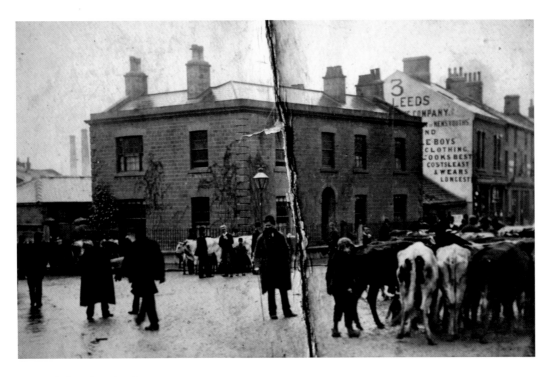

Christ Church Vicarage

Erected on land given by Skipton's parish church for the endowment of the new Christ Church, the vicarage was built in 1837. The tithe barn, squeezed between the vicarage and another building, was demolished in 1901 to make way for Mr A. R. Stockdale's Wine and Spirit Lodge. Its thatched roof was removed by Mr Thornton and re-covered with stone slates. The vicarage was converted in 1901 to a block of shops.

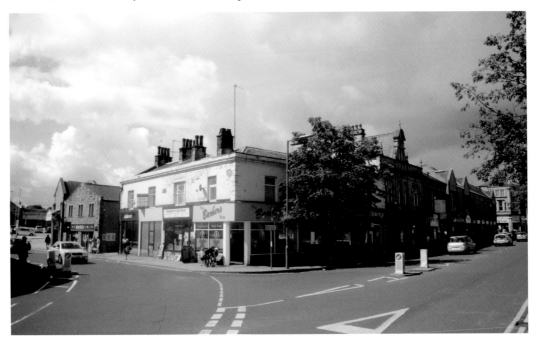

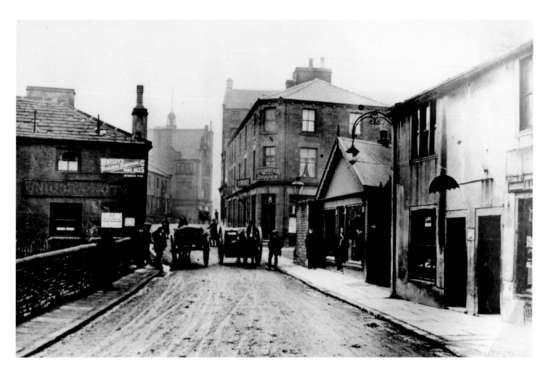

Keighley Road

All the buildings in Keighley Road have now been demolished except for the one in the distance. On the left is the bridge parapet of the beck, which caused the flood already mentioned. The Unicorn was rebuilt and part of it can be seen in the recent photograph. The demolition of the buildings on the right made way for a car park and entrance to the bus station.

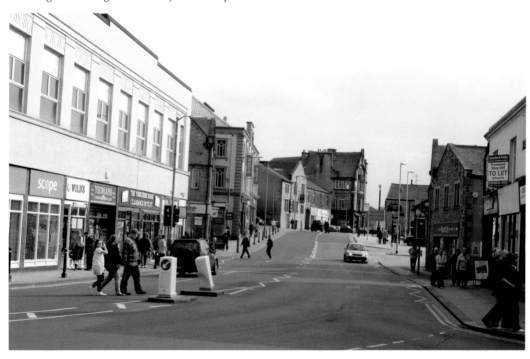

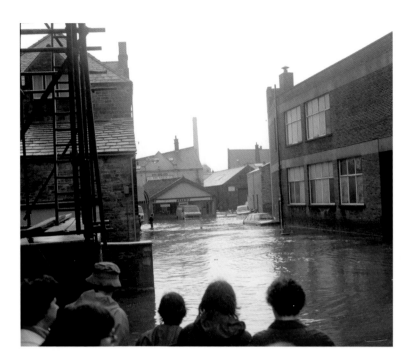

Devonshire Street in the 1979 Flood

In 1979, much of the floodwater came from the beck behind here that went into a culvert under Devonshire Street, seen here. The red Laycock's van floated down the street from their premises behind and into Meakin's. Also behind are the streets where eighty-nine-year-old Jane Barraclough drowned. She was found floating face down in her living room in Brookside. Today, Meakin's shop has gone and on the left is a car radio shop. Next to it is the popular Aagrah restaurant.

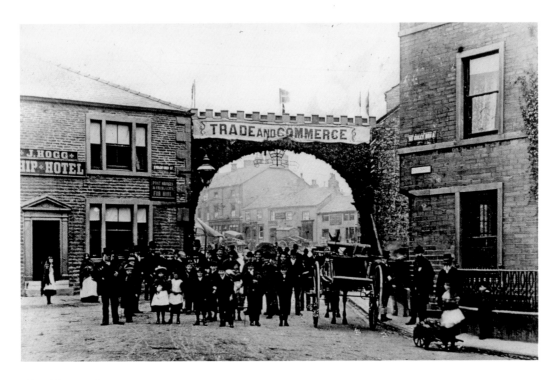

The Ship Hotel

John Hogg was landlord of the Ship Hotel from 1874 to 1885. At that time Ship Corner was only twenty-three feet wide at its narrowest point. The building on the right was Skipton post office. The arch was erected in celebration of the Craven Agricultural Society Show. Built in its place, in 1888, was the new Ship hotel, which eventually closed in 1924. It was associated with Thomas Cook, the travel agents, who organised a timetable for coaches to run to the railway station.

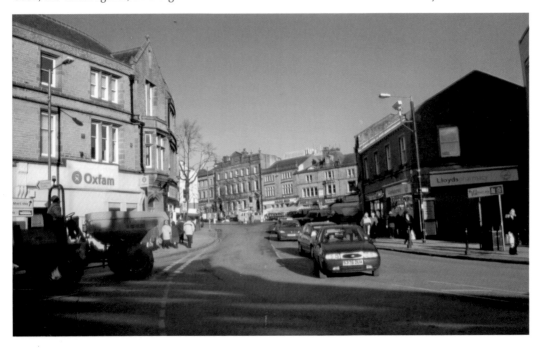

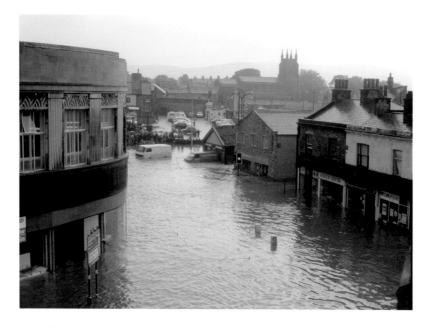

The Flood of 1979

The flood of 1979 was contained in Swadford Street and Keighley Road by the slight hills into the High Street, Belmont Bridge and at Keighley Road just beyond the white van. These scenes are from my old dental surgery, now Dolland & Aitchison. A fine net now covers the balcony to keep out pigeons.

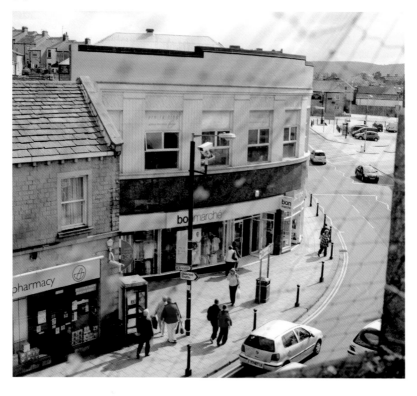

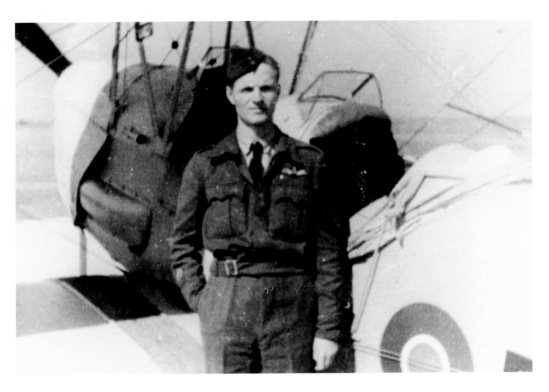

The Author Through Time
The older image was taken in 1946, at Carlisle Elementary Flying School, and the serial number of the plane is only one different from the one in the author's possession today, shown in the lower picture.

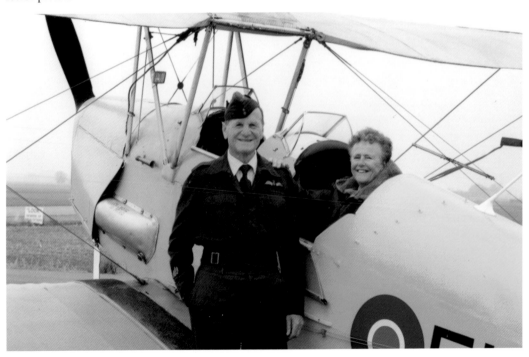